Postcard History Series

Panama City

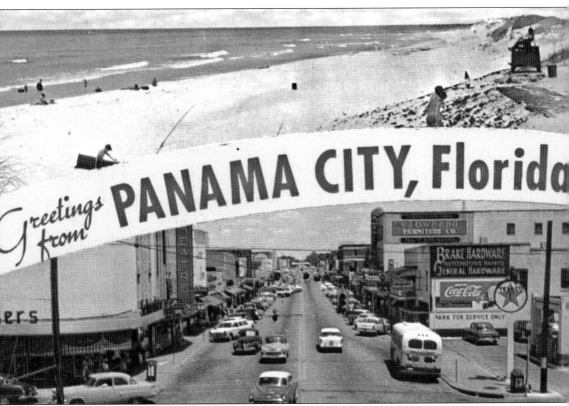

MULTI-VIEW OF PANAMA CITY. At the top is a typical scene of the beautiful white-sand beaches located west of downtown Panama City. The lower view is a busy street scene looking north in the 400 block of Harrison Avenue. At the left is the old Ritz Theatre, now the Martin Theatre, which is currently used as a live performing arts center.

On the Front Cover: This is the *Tarpon*, owned by the Tarpon Steamship Company and captained by Willis G. Barrow, which began coming to St. Andrews as early as 1898. It is docked in Panama City, and the gentlemen in their fine suits and hats appear to be there for some special occasion. The *Tarpon* made 1,735 round-trips between Mobile, Pensacola, Panama City, Apalachicola, and Carrabelle before it sank in a storm on September 1, 1937. (Postcard courtesy of Janet Givens.)

On the Back Cover. Gideon Thomas started construction of this two-story hotel in March 1935 on 104 acres he purchased east of Long Beach. He called it the Panama City Beach Hotel, making it the original Panama City Beach hotel. He also built 30 cottages, a water tower, three windmills, and a 1,000-foot pier. It opened on May 2, 1936, and was located on what is now Thomas Drive, which was named in his honor in 1953.

Postcard History Series

Panama City

J. D. Weeks

Copyright © 2005 by J. D. Weeks
ISBN 0-7385-4185-0

Published by Arcadia Publishing
Charleston SC, Chicago IL, Portsmouth NH, San Francisco CA

Printed in Great Britain

Library of Congress Catalog Card Number: 2005928066

For all general information contact Arcadia Publishing at:
Telephone 843-853-2070
Fax 843-853-0044
E-mail sales@arcadiapublishing.com
For customer service and orders:
Toll-Free 1-888-313-2665

Visit us on the internet at http://www.arcadiapublishing.com

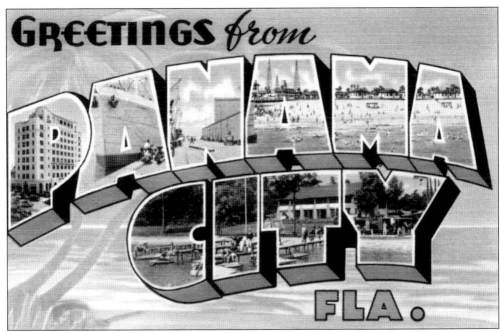

TYPICAL "GREETINGS" POSTCARD FROM PANAMA CITY, FLORIDA. This is a typical "Greetings" style postcard using actual postcard views incorporated into the lettering of the title. Almost every publisher of Panama City postcards had some variation of this style utilizing many different local views.

Contents

Acknowledgments	6
Introduction	7
1. Downtown Panama City	9
2. St. Andrews, Bunker's Cove, and Other Communities	23
3. The Original Panama City Beach	41
4. Long Beach Resort	47
5. Thomas Drive	59
6. Beach Motels and Cottages	67
7. Amusements and Things to Do	93
8. Restaurants and Places to Eat	101
9. Miscellaneous	115
Bibliography	128

Acknowledgments

Many people helped with this effort, and for that I am truly appreciative. The Bay County Public Library has been a wonderful resource, especially the Local History Room with Rebecca Saunders and Anita Lucas. The Historical Society of Bay County, of which I am now a member, and their *Historic Sites Survey* was a plethora of information.

A special thanks to Mr. Tommy Smith, well known for the many books and publications he has written to preserve the local history of Panama City and Bay County, for giving me time in his home for my many questions, as I enjoyed an ice-cold glass of tea and a wonderful view of Johnson Bayou from his window.

I enjoyed my conversation about the old Panama City Beach Hotel with Mrs. Claudia Pledger, who is 104 and answered the phone when I called. I appreciate very much the Long Beach Resort information and pictures provided over the last several years by Mr. Guy Churchwell and his daughter, Kay Churchwell.

Other helpful contributors were: Mrs. Maggie Lee Mench Andrews, Bill Buskell of Pineapple Willy's, Nancy Parker Carter, and Janet Givens, who allowed me the use of some of her early downtown Panama City postcards.

And we cannot forget the local postcard publishers who were responsible for most of those beautiful Panama City postcards. Their wonderful postcard views were enjoyed years ago when sent and received but now even more by postcard collectors and others who enjoy local history. The most prolific publishers were Cooper's News Agency and the Dothan Cigar and Candy Company. Some of the earliest included Panama City Publishing Company, Sims Drug, and E. W. Masker, who also provided many of the early wonderful photographs.

Thanks also to my grandchildren, Jarred Brittian, Christopher Shelnutt, Matthew Shelnutt, James Brittian, Edmund Weeks, Hugh Weeks, Elizabeth Shelnutt, and Jonathan Shelnutt, who helped with selection of the postcards. All are now six years older since they last helped in 1999 with my Birmingham postcard book.

This book is dedicated to the loving memory of my precious grandson Stephen Middleton Weeks.

Introduction

 The first documented settlement in the St. Andrews Bay area began in 1827 when John Clark, former governor of Georgia, built a home in the vicinity of Beach Drive and Frankford Avenue, near Lake Caroline. He had been appointed by his good friend Andrew Jackson to be protector of the timber around St. Andrews Bay, which was used to build federal ships. A few years earlier, Andrew Jackson had been appointed the first military governor of the Florida Territory. Only a few people resided there year-round at that time. On March 9, 1843, the Florida Territorial Council chartered a town for St. Andrews Bay. Two years later, the first post office was established there.
 Mail service was discontinued during the Civil War. St. Andrews burned in 1863 when U.S. gunboats shelled the area in an attempt to break up the salt-making activities of the Confederates. There was a skirmish on May 20, 1863, between sailors from a federal gunboat and Confederate soldiers. A historical marker designates the site of this skirmish on Beach Drive.
 By 1879, Lambert Milford Ware purchased property and built a 50-foot wharf at the site of the old Ramada Inn at St. Andrews. The area became known as Wareville. The lake feeding into the bay there was named Ware Lake, which today the Cabana Motel sits upon. The second post office was established on December 12, 1881, and in 1887, the *St. Andrew Messenger* became the first newspaper in the area.
 The current site of downtown Panama City began as three homesteads of 640 acres each in the 1880s. First called Floropolis, it was named Harrison in 1889. That same year, the St. Andrews Lumber Company was built in the Millville area, and a post office was established there. Land patents had been secured in the Millville area as early as 1837 by James and Terry Watson, for whom Watson Bayou was named. The post office in Harrison was closed in 1904, and the future Panama City was served by the Millville Post Office until the Harrison Post Office reopened in 1906.
 St. Andrews was incorporated in 1908, Panama City was incorporated in 1909, and a few years later, Millville incorporated on July 1, 1913. Then in 1926, through an act of the Florida Legislature, St. Andrews and Millville became a part of Panama City. In 1929, with the opening of the Coastal Highway (now U.S. 98) and the Hathaway Bridge, the land connection was made to those beautiful white-sand beaches to the west of Panama City. That ended the ferry rides, boat rides, or that long drive around West Bay to get there.
 Now let's move on to the early development on the beach side of Hathaway Bridge. The Long Beach area had been homesteaded by Hubert Brown in the 1920s. W. T. Sharpless purchased land there about 1928 and became a partner with Brown when they purchased a building

known as the Pavilion. They moved it, from what is now Shell Island, over the sand by mule and wagon. The building had a huge wooden floor above some bathhouses, which were rented. J. E. Churchwell purchased Long Beach, which included 220 acres, from them in 1932 for $10,000. He constructed some rental cottages and dug a well for a water supply. Later he built the famous Hang Out by the beach.

Just east of Long Beach, Gideon Marion Thomas purchased 104 acres in March 1935 and began construction of a 12-room, 2-story hotel, which he named the Panama City Beach Hotel. He had moved there in February from his 2,000-acre deer farm on Camp Flowers Road. Included at Panama City Beach were some cottages, a water supply, three windmills, and a 1,000-foot pier. Unfortunately Gideon died in 1937; his daughter, Claudia, and her husband, Angus W. Pledger, continued the development. Later they built the famous entrance arch that welcomed everyone to Panama City Beach. A post office was opened in 1939 at Panama City Beach, and Angus Pledger was appointed postmaster. In 1953, Panama City Beach was incorporated. In the first election, Claudia Pledger was elected mayor. That same year, Thomas Drive was named for her father, Gideon Thomas, who had developed the original Panama City Beach and whose land was used to create part of Thomas Drive.

In the meantime, J. E. Churchwell continued to build his empire, which is remembered today as Long Beach Resort. The development there grew to include cottages, a casino, a restaurant, amusement rides, a skating rink, mini golf, a barber shop, a grocery store, a gas station, a souvenir shop, a shooting gallery, Petticoat Junction, Ghost Town, and, of course, the Hang Out.

In 1970, all the different municipalities that had incorporated along the Miracle Strip were merged into the new Panama City Beach just in time to prepare for the coming condominium explosion only a few years away.

So what happened to these early developments that got it all started down there on the "World's Most Beautiful Bathing Beaches"? Well it seems that all good things must come to an end, and the first to go was the Panama City Beach Hotel, which burned sometime before 1956. It later became a bait shop. The pier was heavily damaged by Hurricane Eloise in 1975. The cottages are long gone, but now the very popular Pineapple Willy's sits on the historic remains of the old 1,000-foot pier. Long Beach Resort continued to thrive until Hurricane Eloise hit it as well, destroying the Hang Out and heavily damaging the casino. It finally closed, and in 1984, everything was auctioned off, including the trains and track of Petticoat Junction. One of the trains and three miles of track went to a huge mansion north of Birmingham. Now a Wal-Mart Super Center sits in the middle of the old Petticoat Junction rail route, and the old site of Ghost Town is now an Applebee's.

Maybe this little book will help some to remember how it was back then and introduce others to a wonderful time in our history.

One
Downtown Panama City

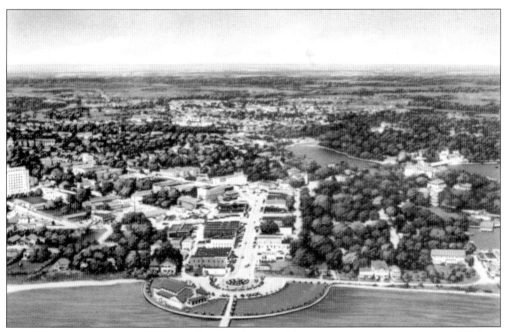

AERIAL VIEW OF PANAMA CITY. This aerial view of downtown Panama City is most likely in the early 1940s, since the USO Building can be seen on the circle near the pier. The 10-story Dixie-Sherman Hotel, built about 1926 by W. C. Sherman, can be seen on the left. The rooftop garden provided a magnificent view of St. Andrews Bay to thousands of people before it was demolished in 1970.

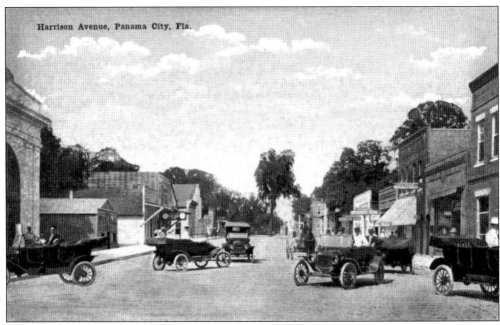

HARRISON AVENUE. This view of Harrison Avenue appears to be around 1915. The streets are still dirt. With a magnifying glass, the sign for Sims Drug Company, also the publisher of this postcard, can be seen on the right side of the street. This identifies the location as the 100 block on Harrison Avenue. (Postcard courtesy of Janet Givens.)

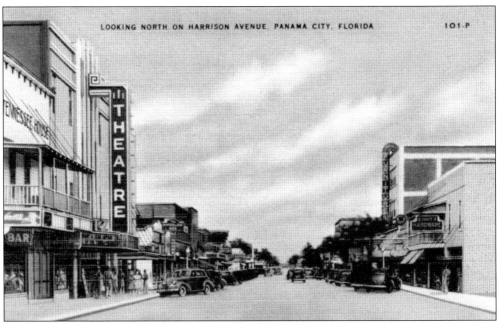

LOOKING NORTH ON HARRISON AVENUE. The movie playing at the Ritz Theatre dates this view as 1942, the release date of *The Talk of the Town*, starring Cary Grant, Jean Arthur, and Ronald Coleman. An unknown, uncredited actor, Lloyd Bridges, had a small part. This postcard was mailed by a young lieutenant stationed at Pensacola to his family in Washington State.

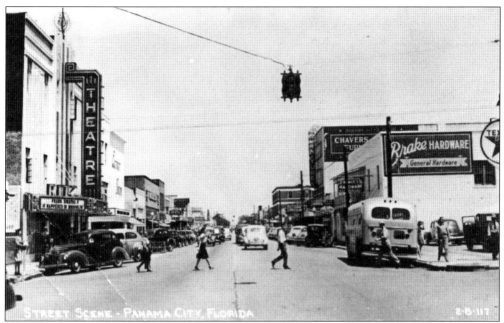

STREET SCENE. This real-photo postcard is a view of the 400 block of Harrison Avenue looking north. At the end of the block on the right is Hotel Marie. On the left, you can see the Ritz Theatre, and at the end of the block is Childs Drugs. Playing at the Ritz Theatre is *It Happened in Brooklyn*, starring Frank Sinatra, which dates this photo to 1947. The theatre, now the Martin Theatre, is currently used as a live performing arts center.

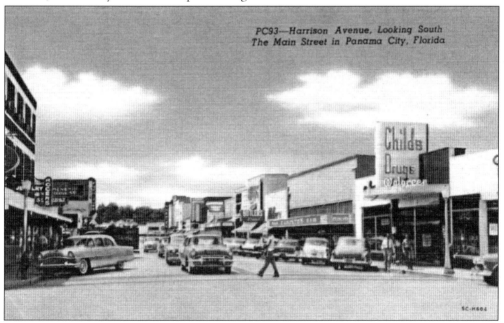

HARRISON AVENUE. This is a view of Harrison Avenue looking south toward St. Andrews Bay. Childs Drugs, owned by Porter B. Childs, is located on the corner of Harrison Avenue and Fifth Street. Farther down the street can be seen Christo's 5 and 10 and Butler's Shoes. This postcard, mailed in 1957, shows a mixture of 1940s and 1950s automobiles on the street.

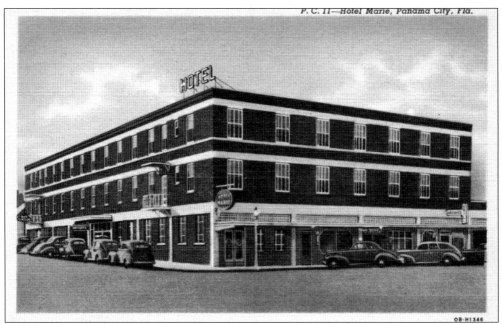

HOTEL MARIE. The Hotel Marie was built by A. R. Rogers in the 1930s on the corner of Fifth Street and Grace Avenue and named after his wife, Marie. The grand opening ball was on February 4, 1939. The sign at the right end of the building advertised that Archie's Grill was located there; at the other end of the building was the bus station. The Hotel Marie closed around 1985 and sits vacant in 2005.

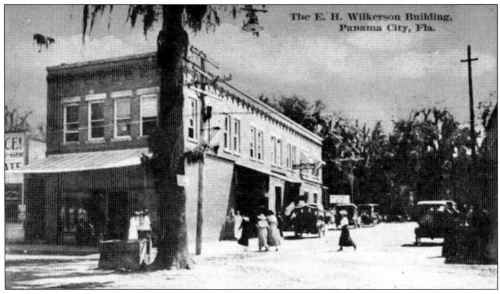

THE E. H. WILKERSON BUILDING. The Wilkerson building was built by the Asbell Brothers in 1913 on the corner of Harrison Avenue and Oak Street. The owner was E. H. Wilkerson, who also owned the Panama Jewelry Company, which was located there until 1925. Other early tenants were Childs and Johnson Drug, Sanderfer Jewelry, Eddins Café, Law Office of Price and Grace, the post office, Cain Realty, the chamber of commerce, and the Sherman Arcade. (Postcard courtesy of Janet Givens.)

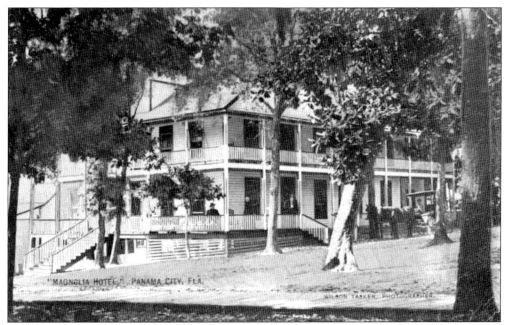

MAGNOLIA HOTEL. The Magnolia Hotel, one of the first Panama City hotels, was built about 1912 at Fourth Street and Grace Avenue. It was operated by the Reynolds family. As with many of the wooden structures of the time, it burned. This postcard, made from a Wilson Tasker photograph, was mailed to Waycross, Georgia.

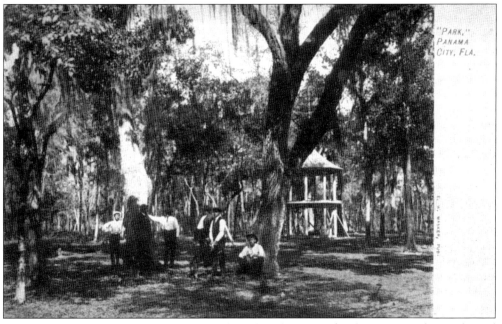

PARK. This park was included in the early plats when the town of Park Resort was being planned in the late 1800s. It opened in 1906 and was first called Fairy Park and later named City Park. In 1964, it was renamed McKenzie Park after Robert Lee McKenzie, who was the first mayor of Panama City in 1909. The McKenzie home is located at the edge of the park. (Postcard courtesy of Janet Givens.)

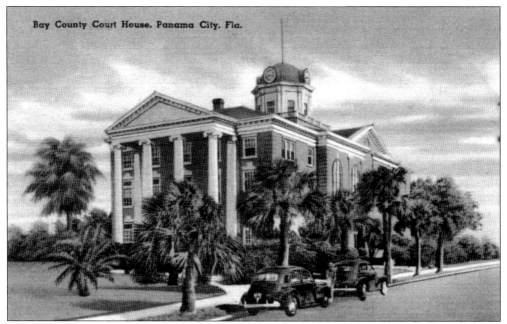

COURT HOUSE. The Bay County Court House was built in 1914 at 300 Fourth Street and included a dome and clock tower. Bay County was formed by carving out portions of Calhoun and Washington Counties in 1913. The courthouse was destroyed by fire in December 1920.

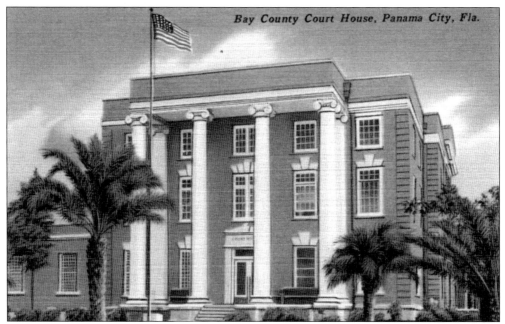

REBUILT COURT HOUSE. This is a view of the rebuilt courthouse after the 1920 fire. The dome and clock tower were not included in the new building. The Bay County Courthouse was the scene of a historic case (Gideon v. Wainwright 1963) that resulted in the U.S. Supreme Court decision that defendants with no means were to be supplied with a court-appointed attorney. Fred Turner, a local attorney, represented Clarence Earl Gideon.

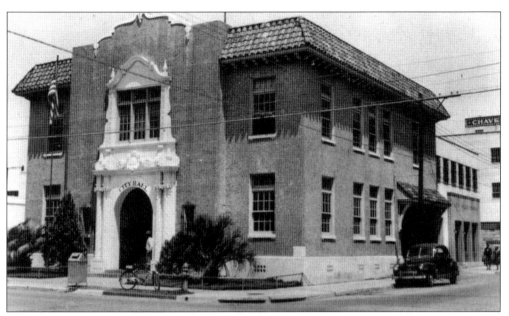

CITY HALL, *c.* 1940. This real-photo postcard depicts the old city hall in Panama City in the late 1930s. It is located on Fourth Street, east of Harrison Avenue. The rear right side of the main building housed the fire truck. The rear adjoining building housed the jail facilities. A new city hall was built in the 1960s at the Panama City Marina Complex. This building, renovated in 1986, became home to the Visual Arts Center. (Postcard courtesy of Janet Givens.)

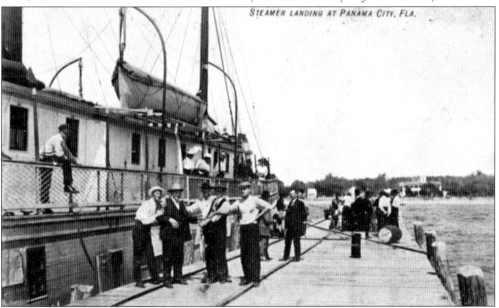

STEAMER, *c.* 1920s. This is the *Tarpon*, owned by the Tarpon Steamship Company and captained by Willis G. Barrow, which began coming to St. Andrews as early as 1898. It is shown docked in Panama City, and the gentlemen in their fine suits and hats appear to be there for some special occasion. The *Tarpon* made 1,735 round-trips between Mobile, Pensacola, Panama City, Apalachicola, and Carrabelle before it sank in a storm on September 1, 1937. (Postcard courtesy of Janet Givens.)

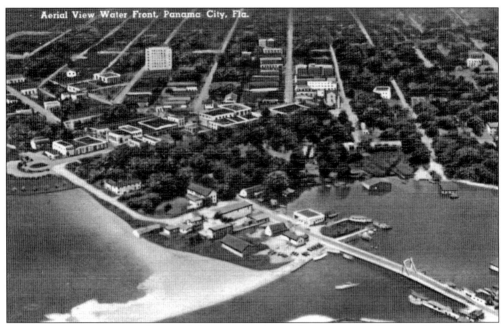

WATER FRONT. This aerial view of the city also shows the Tarpon Dock, located at the bottom right of this postcard view. Built by the Tarpon Steamship Company, the first bridge was constructed of wood over the Massalina Bayou. The bridge displayed here was built later and named the Frank Nelson Bridge in 1951.

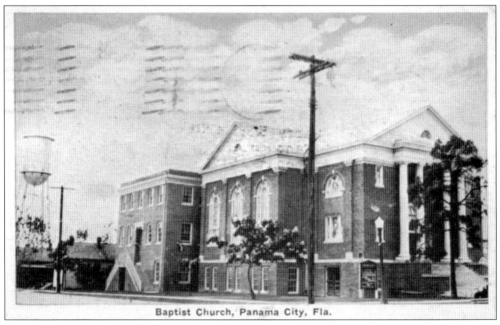

BAPTIST CHURCH, c. 1920s. The Baptist church was meeting in the Tennessee House in 1909 and then built this building in 1910 at the corner of Grace Avenue and Fifth Street. They moved to their current location at Sixth Street and Harrison Avenue in 1926. The postcard writer relates that she was staying in "Apt. #3 at the Cove Apartments."

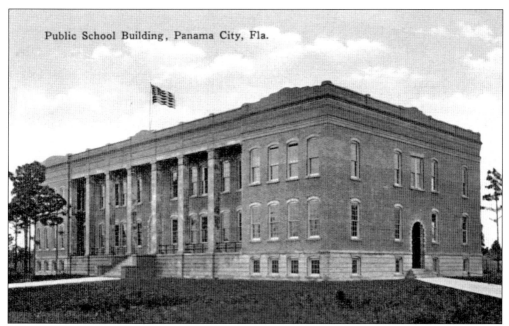

PUBLIC SCHOOL BUILDING, *c.* 1913. This school began as the Panama Grammar School in 1913 and later became a high school. It was located at Luverne Avenue and Eighth Street in downtown Panama City. It was renovated in 1951, and in 1965, it was sold to the Wallace Memorial Presbyterian Church and the Medical Arts Center, where it still stands as stately as ever. (Postcard courtesy of Janet Givens.)

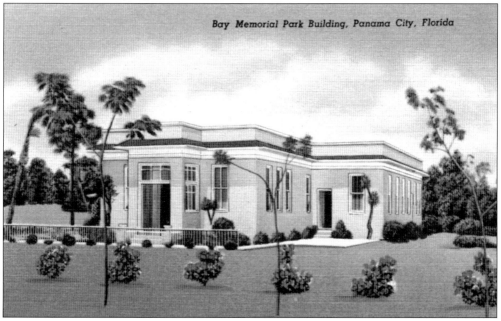

BAY MEMORIAL PARK BUILDING. The Bay Memorial Park Building was built in 1907 as the first Panama Grammar School. In 1914, it became the First Presbyterian Church. It was moved to its current location at 810 Garden Club Drive and became the Bay Memorial Park for the Panama City Garden Club. It is a living memorial to those who died in war from Bay County.

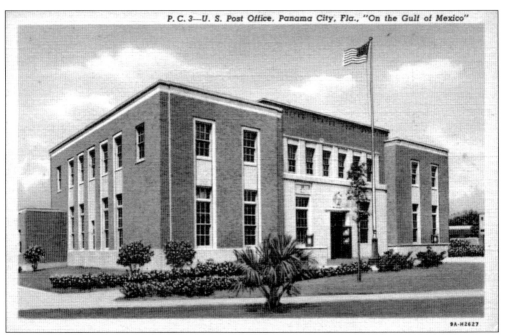

U.S. Post Office. This is a 1939 postcard view of the post office, which is located at 421 Jenks Avenue. Construction of this building began in 1937 as a Works Progress Administration (WPA) project. It was dedicated on April 29, 1938, and is still in use today.

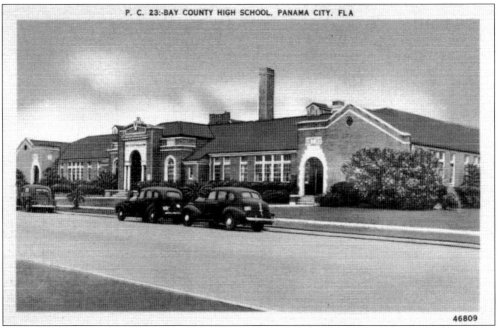

Bay County High School, *c.* **1930s.** Bay County High School was built in 1926. In 1927, the Panama High School merged with Bay County High School to form one high school for all of Bay County. Later the name was shortened to Bay High School.

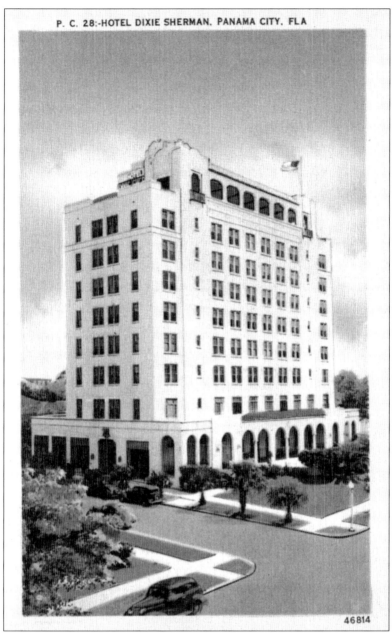

HOTEL DIXIE SHERMAN. The Dixie Sherman Hotel, Panama City's first "skyscraper" with 10 floors, was built about 1915 by W. C. Sherman on the corner of Jelks Avenue and Fifth Street. On the main floor were the lobby and some offices. The second floor had a large dining room and banquet hall. The rooftop garden provided a magnificent view of St. Andrews Bay and was a favorite place to make photographs. This postcard boasts of having 100 rooms with baths and being fireproof. It was open year-round, catering to both commercial and recreational patrons. It also offered special services to those vacationing with experienced guides and fishing equipment available. As with any large hotel, it was the primary place for social events and civic activities. The building was destroyed with dynamite in 1971 after unsuccessful attempts to demolish it using traditional methods.

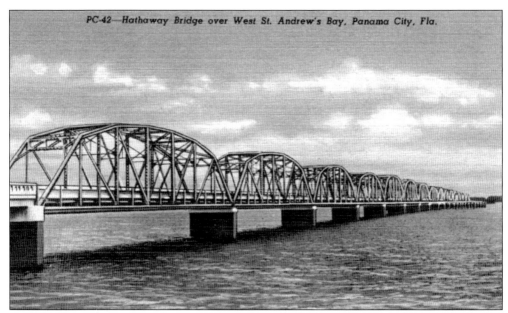

HATHAWAY BRIDGE. The Hathaway Bridge opened in May 1929. Prior to then, the only access over West Bay was by boat, ferry, or a long drive around. First called St. Andrews Bay Bridge, it was later named for Dr. F. A. Hathaway, the director of the Florida State Roads Department. A toll was charged at first but was discontinued when the Coastal Highway was designated Federal Highway 98. It was replaced in 1959 and then again in 2004.

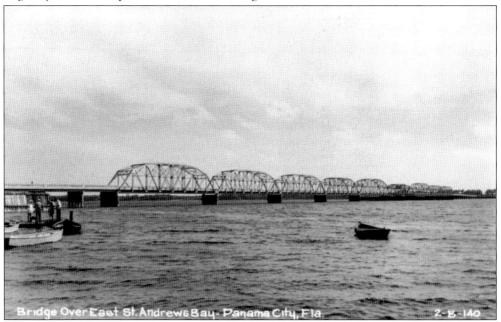

BRIDGE OVER EAST ST. ANDREWS BAY. This bridge opened in April 1929 over East Bay, one month prior to the opening of the Hathaway Bridge. It was replaced by a new bridge and named the Dupont Bridge after A. I. Dupont, the president of the Gulf Coast Highway Association. That association was formed by citizens who campaigned for the construction of a coastal highway along the gulf.

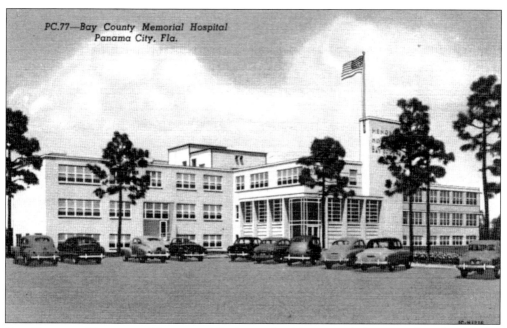

BAY COUNTY MEMORIAL HOSPITAL. The image for this postcard view was taken shortly after the hospital opened. It was chartered in 1949 as Memorial Hospital of Bay County. Located at 615 North Bonita Avenue, it is now known as the Bay Medical Center. It has grown to 403 beds and is the only open-heart surgery program within 100 miles.

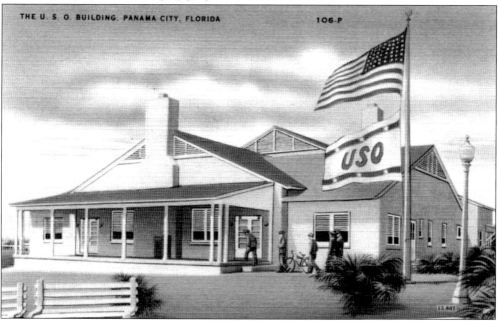

U.S.O. BUILDING, c. 1944. The USO Building opened on April 1, 1942, on the circle at the foot of Harrison Avenue. One can only imagine how the servicemen must have enjoyed going there to forget about the raging World War II. The building can be seen on the left of the circle in the view on page nine. After the war, it was a favorite place for the high school to have proms. The USO Building later became the civic center building.

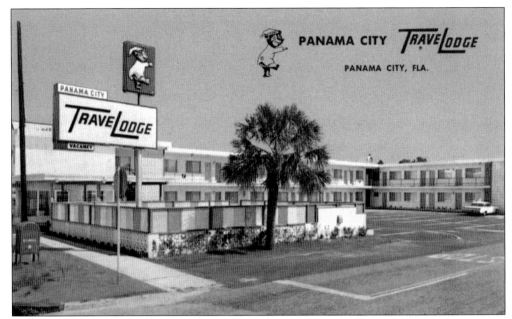

PANAMA CITY TRAVEL LODGE, c. 1970s. The Travel Lodge Motel was located at 900 Harrison Avenue, right on U.S. Highway 231. It had 36 units with central heat and air, a coffee shop, and a heated pool. The old familiar sleepy bear symbol is long gone from this location. The building is still there, but it is now a Relax Inn.

MARIE MOTEL, c. 1950s. The Marie Motel is located at 545 Magnolia Avenue. In this late 1950s view, the owner is listed as A. R. Rogers and the manager is L. L. Harrell. This postcard was mailed to Evansville, Indiana, and the writer says they are having a relaxing time, that Panama City was much more than he expected, and the beaches are crowded.

Two

St. Andrews, Bunker's Cove, and Other Communities

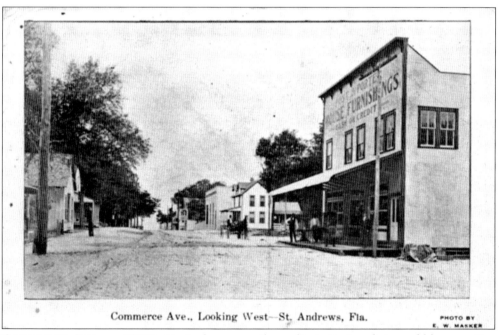

COMMERCE AVE., c. 1890S. St. Andrews was the earliest city in what would become Bay County. This was the main street in early St. Andrews where the business community first began to grow. The horse and buggy was the primary mode of transportation on land, although there was a stagecoach stop in the 1890s. St. Andrews Bay can be seen in the background. (Postcard courtesy of Janet Givens.)

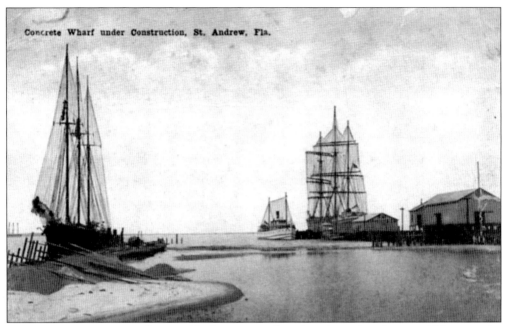

CONCRETE WHARF. Lambert Milford Ware purchased property in what would become St. Andrews in 1879 and opened a mercantile business. He constructed this 50-foot wharf, which became known as Ware Wharf. The lake just west of this site is still called Lake Ware. (Postcard courtesy of Janet Givens.)

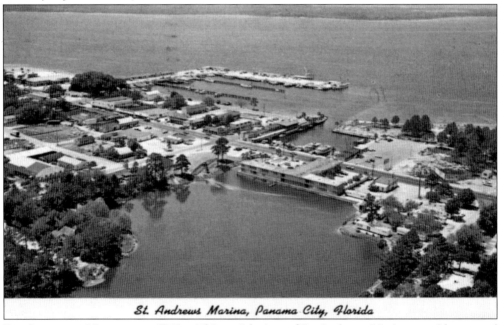

ST. ANDREWS MARINA, c. 1970s. This aerial view of St. Andrews Marina provides a good look at Lake Ware in the foreground. That is Beck Avenue running between the marina and Lake Ware. William and Calvin Smith opened the Shrimp Boat Restaurant on Beck Avenue in 1952. Lowe Smith purchased it later and built the Copa Cabana Motel across the street in 1960 on Lake Ware. The Shrimp Boat was torn down in 1993, but the motel is still operating.

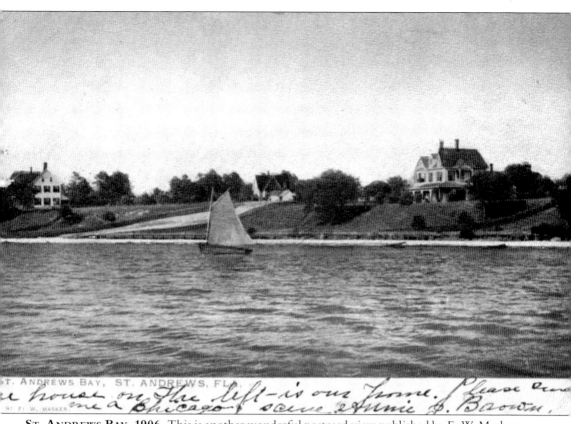

ST. ANDREWS BAY, 1906. This is another wonderful postcard view published by E. W. Masker. Fine large homes were built on the hill above St. Andrews Bay in 1887. One of these was the residence of James H. Brown, who was sent by his company, the Cincinnati-based St. Andrews Bay Railroad, Land and Mining Company, to purchase and sell land. He was the assistant general manager with the company and moved to St. Andrews to act as their agent. This period in St. Andrews history was called the "Cincinnati Boom," and thousands of people bought land and settled there. This postcard was actually mailed by James H. Brown's wife, Annie J. Brown, on June 12, 1906, from St. Andrews to Chicago. In the message, at the bottom of the postcard, she states that her house is on the left and to please send her a Chicago scene. The house on the right was built by the company to house guests traveling there to purchase land. It later became a hotel known as the Villa and sadly was torn down in the 1960s. (Postcard courtesy of Janet Givens.)

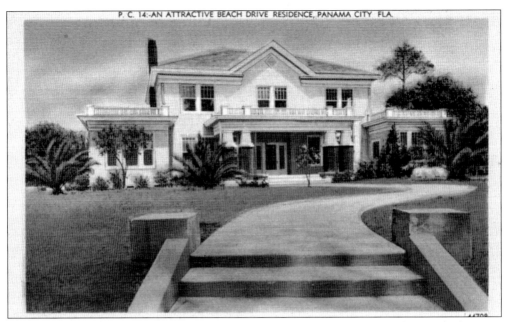

BEACH DRIVE RESIDENCE. This residence is located on West Beach Drive overlooking St. Andrews Bay. It was originally the home of A. A. Payne, who was president of the First National Bank in Panama City. The bank, one of the first in Panama City, was chartered in 1913. On May 20, 1863, there was a Civil War skirmish nearby between a Union gunboat and some Confederate soldiers over a nearby spring. This beautiful home, built before 1927, still looks the same.

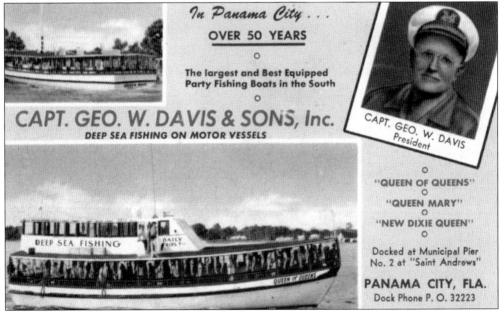

CAPT. GEO. W. DAVIS & SONS. Capt. George W. Davis had three charter boats docked at Municipal Pier No. 2 at St. Andrews. The phone number of his dock phone dates this postcard from the 1950s to the mid-1960s. Captain Davis advertises on the back of this postcard that he has the largest and best-equipped party fishing boat in the South. He also serves complete meals on board and has cold drinks, beer, candy, cigarettes, finger guards, and seasick pills.

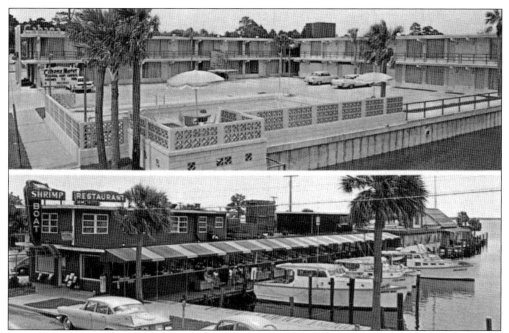

SHRIMP BOAT RESTAURANT, c. 1960s. This is a closer split view of the Cabana Motel and the Shrimp Boat Restaurant, shown previously in the aerial view at the bottom of page 24. The Shrimp Boat was a popular spot to eat supper and watch the fishing boats return with their day's catch. It is sad to see that empty spot where it sat until 1993.

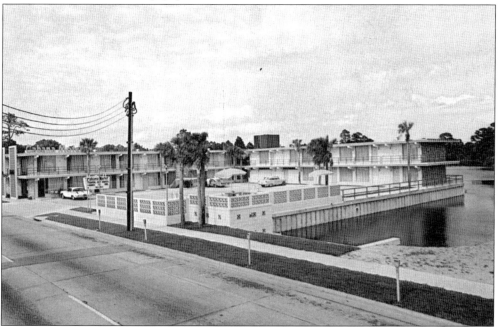

CABANA MOTEL, c. 1960s. This view illustrates how the Cabana Motel is built into and surrounded at the rear by Ware Lake. Thousands of vacationing fishermen have stayed at the Cabana and gone deep-sea fishing across the street at the Yacht Basin. The Cabana was located at 1212 Beck Avenue on Highway 98 West, now Business Highway 98.

HOLIDAY INN #1. The Holiday Inn was the first motel chain to come to Panama City, and this was the first location. Cliff Stiles of Birmingham developed this one and two other Holiday Inns located on the beach. Angelo Gus Butchikas moved his original Angelo's Steak House here from downtown Panama City before moving closer to the beach. This later became a Best Western and now is the Days Inn Bayside.

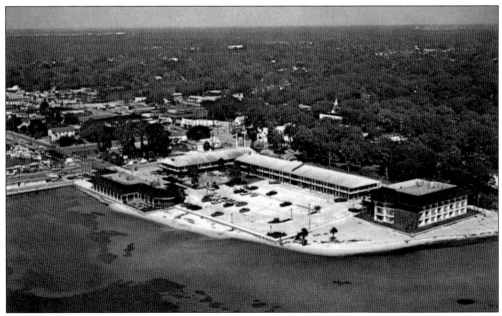

RAMADA INN. This Ramada Inn was located just east of the St. Andrews Marina. With 150 luxury units and their own white-sand beach, it was a convenient place to stay, with deep-sea fishing only a few steps away. Sadly to say, the old Ramada Inn is no longer there, and a huge condominium complex is taking its place.

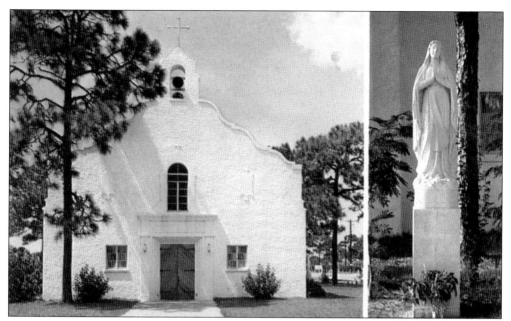

ST. JOHN'S CATHOLIC CHURCH. A Catholic church was in St. Andrews as early as 1890. A Catholic cemetery is at Frankford Avenue and Fifteenth Street where a Catholic church had been built about 1918. It burned in the 1930s and was replaced in 1945 at 1807 Fortune Avenue. The old church still stands looking good as ever; however, a new larger church is standing to the left.

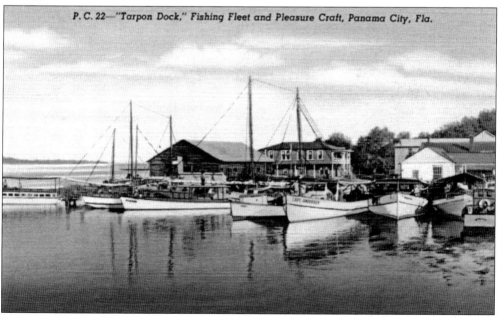

"TARPON DOCK." Now we are moving out of St. Andrews to the east side of Panama City in what is called the Cove. There is an aerial view of the Tarpon Dock on page 16, and this is a closer view at the mouth of Massalina Bayou. If you look closely, you can see that one of the boats is named *Captain Anderson*, a name that would become synonymous with fine dining in Panama City.

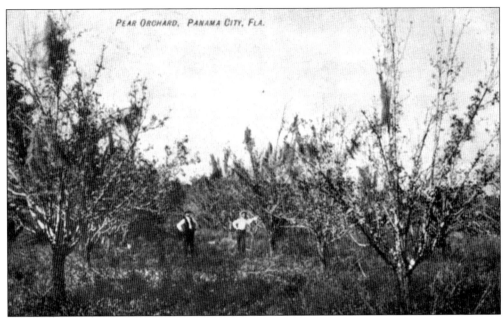

PEAR ORCHARD, 1907. This postcard view, published by E. W. Masker, of a pear orchard was mailed from the post office at St. Andrews on August 11, 1907. This pear orchard was located east of Millville and Watson Bayou and north of Sixth Street. Mailed to Hebron, Illinois, the postcard contained a typical message of the time. The writer says, "We are all well, and send our love to you. Why don't you write?"

ST. ANDREWS BAY YACHT CLUB. This postcard was mailed in 1955, so this is most likely a 1950s view of the St. Andrews Bay Yacht Club, or perhaps it could be a little earlier. It was mailed to Detroit, Michigan, and says that Jack only comes in to eat and sleep and is really getting a Florida tan.

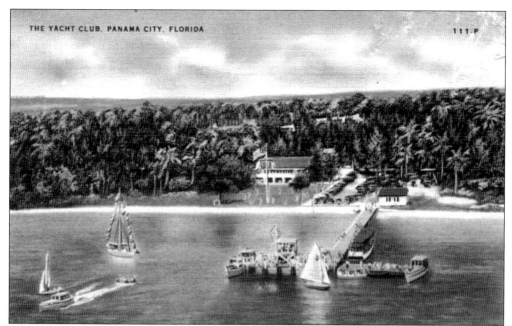

THE YACHT CLUB, c. 1940s. The St. Andrews Bay Yacht Club was established in 1933 on two acres of land in the heart of Bunker's Cove. It is a private club with a family orientation. While this is a 1940s view, as indicated by the postmark, the current facilities are very nice indeed. Amenities include a large dining room, lounge, large ballroom upstairs, swimming pool, and a fleet of sailboats for members' pleasure and racing.

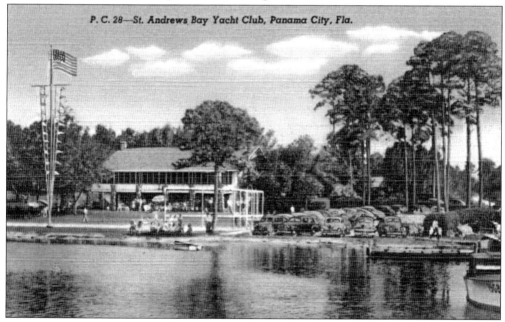

YACHT CLUB, c. 1940s. This is a closer look at the yacht club. Bunker's Cove Road is in the background, out of sight. A baseball game is underway on the front lawn, and that oak tree seen behind the flagpole is surely the huge oak tree that the current outside dining deck is built around.

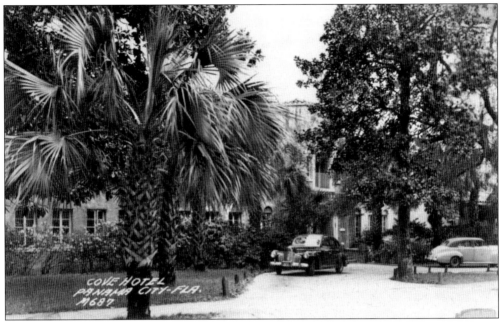

COVE HOTEL, c. 1940s. Construction began on the Cove Hotel in 1925 by H. L. Sudduth, a businessman from Birmingham and the developer of Bunkers Cove. It was completed and opened on Cherry Street in 1927. Sudduth also built a golf course and the St. Andrews Bay Yacht Club (see previous page) in 1933.

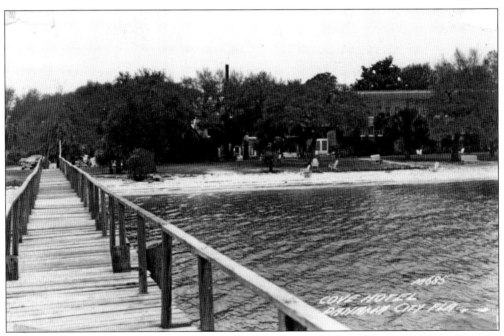

COVE HOTEL, c. 1940s. This is another real-photo postcard view of the Cove Hotel from the pier out into St. Andrews Bay. The Cove Hotel was located at 300 Cherry Avenue, just west of the St. Andrews Bay Yacht Club. It eventually stretched along the bay for a quarter of a mile before being destroyed by fire in 1976.

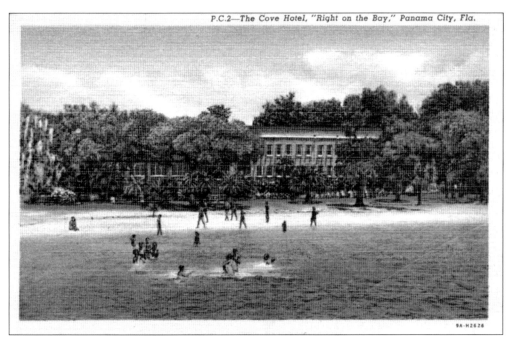

THE COVE HOTEL, 1939. This view of the Cove Hotel shows a large group of "bathers" enjoying the smooth waters of St. Andrews Bay and the beautiful white sand. The pier, seen on the previous page, is just out of view to the viewer's left. It was operated by Robert Sealy and Ruby Harris.

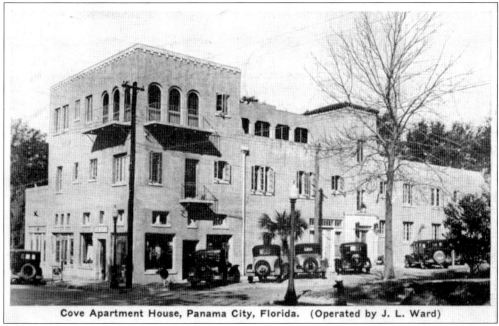

COVE APARTMENT HOUSE, c. 1933. The Cove Apartment House, the first in Panama City, was built in 1928 on Cherry Avenue. This postcard, mailed to Birmingham, Alabama, on July 25, 1933, has a message to "Dad" relating they got up at 4:30 in the morning and went out 50 miles deep-sea fishing, and only one man caught a fish. (Postcard courtesy of Janet Givens.)

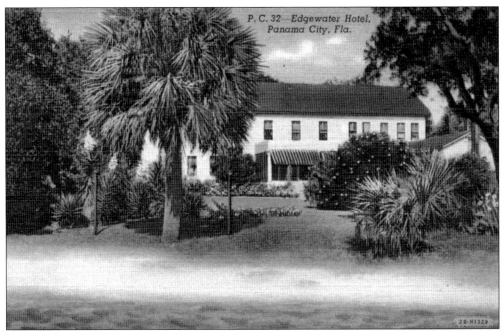

EDGEWOOD HOTEL, 1942. The Edgewater Hotel, built in 1912, was located at 116 East Beach Drive. First known as the Panama Hotel, and the Tex Gilbert Hotel briefly, it became the Edgewater Hotel in 1914. This postcard, mailed on December 5, 1943, was from a Sunday school teacher to someone who evidently had been absent the last Sunday.

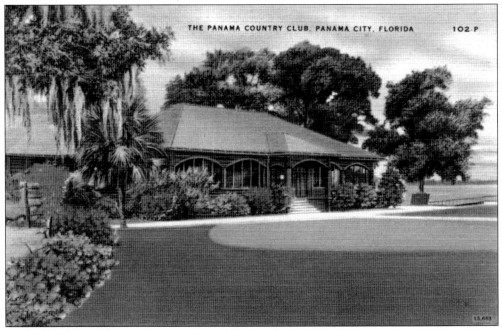

PANAMA COUNTRY CLUB, c. 1940s. The Panama Country Club was built in the 1920s by W. C. Sherman, who also owned the Dixie Sherman Hotel and the Panama Jewelry Company. It is located on the North Bay of St. Andrews Bay at 100 Country Club Drive in Lynn Haven. The publisher of this postcard was Dothan Cigar and Candy Company of Dothan, Alabama.

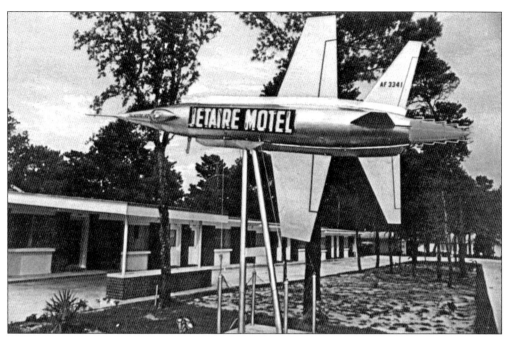

JETAIRE MOTEL. This Jetaire Motel is still operating on Highway 98 East in the town of Parker, minus the jet airplane seen in this postcard view. The postcard indicates it is located one-fourth of a mile from Tyndall Air Force Base and is owned by S. L. Benoit, "SMS USAF Ret."

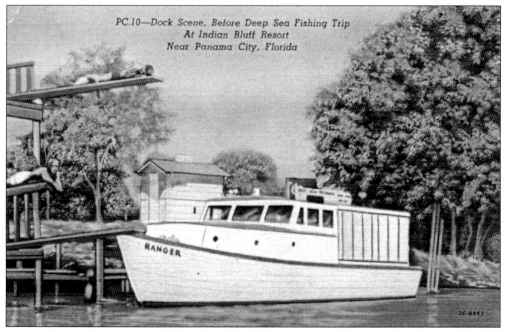

INDIAN BLUFF RESORT, c. 1952. Indian Bluff is located east of Panama City, beyond Tyndall Air Force Base. Fishing boats originated there, navigating out into the Gulf of Mexico. The rivers, bays, and bayous were covered with these small six-party boats for deep-sea fishing.

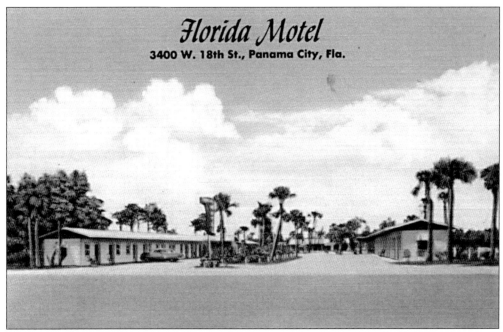

FLORIDA MOTEL. The Florida Motel was located at 3400 West Eighteenth Street. This and the next nine postcard views depict motels located on Eighteenth Street, which is also Highway 98 West. The motels along this route provided vacationers with an economical place to stay away from the heavy beach traffic. The Florida Motel is now the Fairway Inn.

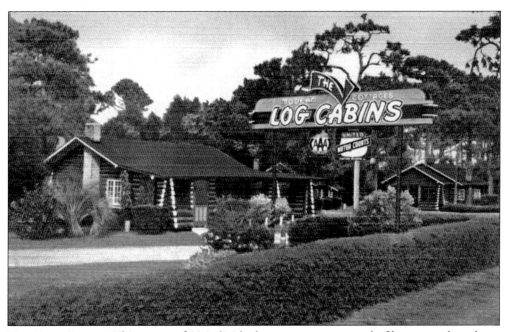

THE LOG CABINS. This group of 20 individual cottages, constructed of logs, must have been pretty easy to spot. Four miles west of the center of town, they were located at 3500 Highway 98 West. They advertised nine of the cottages had kitchenettes, and other amenities were fishing, bathing, gas heat, fans, and mail and bus service. Sadly they have disappeared from the scene.

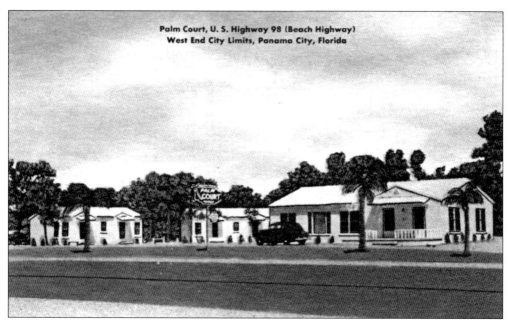

PALM COURT, c. 1949. The Palm Court was at 3910 Highway 98 West. This postcard was mailed on October 17, 1949, to Kansas. The writer says they have stopped here for the night and plan to be in Miami early Thursday. They are also going out to eat and Mildred is going to have seafood. The Budget Inn of Panama City currently sits on this spot.

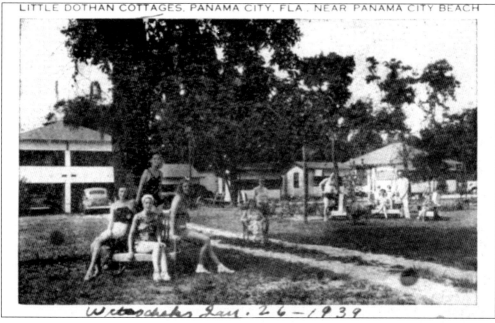

LITTLE DOTHAN COTTAGES, 1939. These cottages were located at 4127 Highway 98 West. This postcard was published by Panama City Publishing Company, another of the local postcard producers. These folks were on their way to New Orleans and evidently stopped off in Mobile, Alabama, to mail this postcard on January 26, 1939. This location now provides a home for Schlotzsky's Deli. (Postcard courtesy of Janet Givens.)

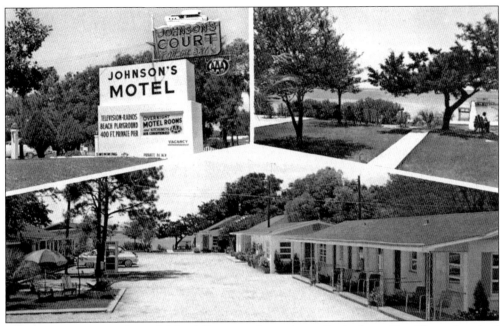

JOHNSON'S MOTEL. Johnson's Motel Court was located near St. Andrews Bay. They advertised rooms and kitchenette apartments with lawns, shade trees, a private beach, swimming, a 400-foot pier, fishing boats, and a restaurant nearby. It was owned and operated by Mr. and Mrs. J. Leonard Johnson.

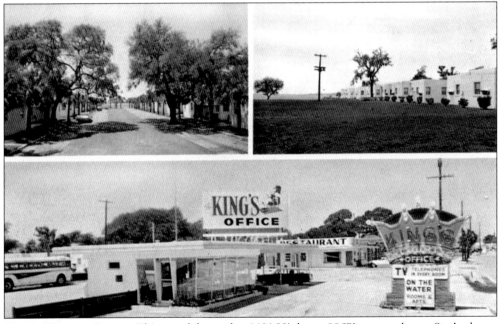

KING'S MOTOR COURT. This motel, located at 4601 Highway 98 West, was also on St. Andrews Bay. They advertised efficiency apartments and two-bedroom cottages, air conditioned, vented panel-ray heat (whatever that is), tile baths, telephone and television in each room, and a connected restaurant. All these cottages have disappeared, and there is now a Howard Johnson Motor Lodge there.

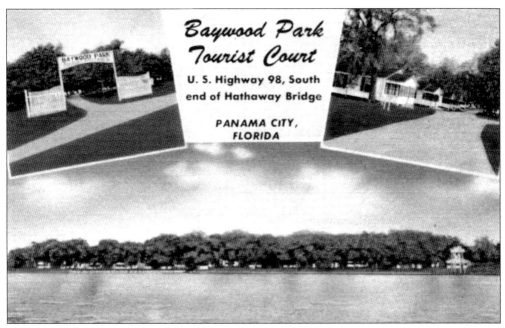

BAYWOOD PARK TOURIST COURT, 1950. As indicated by this view, Baywood Park Tourist Court had a large presence on St. Andrews Bay. Located at the foot of Hathaway Bridge, they provided modern fully equipped cottages with plenty of shade trees. The owner and manager was H. L. Gwin. This postcard, mailed to Kellyton, Alabama, on June 19, 1950, announces the safe arrival of the sender.

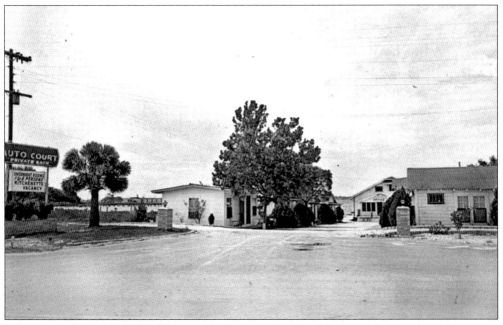

HATHAWAY BRIDGE AUTO COURT. As the name implies, Hathaway Bridge Auto Court was located at the foot of Hathaway Bridge, directly across Highway 98 from the Baywood Park Tourist Court. This business was owned and operated by Elsie and Tom Moore. (Postcard courtesy of Janet Givens.)

EL PINE MOTEL. The El Pine Motel was located at 8901 West Highway 98 on the west side of Hathaway Bridge. It was built and owned by Mr. and Mrs. Melton Nix in the late 1950s. The El Pine is still doing business there and looks pretty much the same.

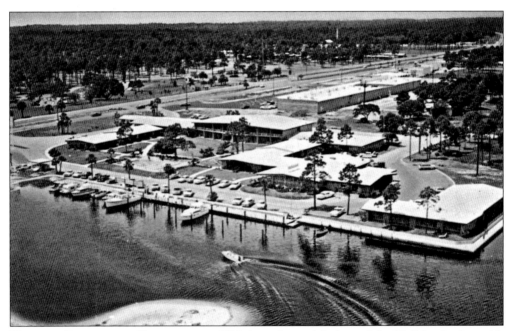

HOLIDAY LODGE AND RESTAURANT. This is a nice aerial view of the Holiday Lodge with Highway 98 West visible toward the top of the postcard. They have a private marina and sport fishing boats at the front door. Other amenities were golf greens, convention facilities, restaurant, lounge, and an adjoining shopping center.

Three
THE ORIGINAL PANAMA CITY BEACH

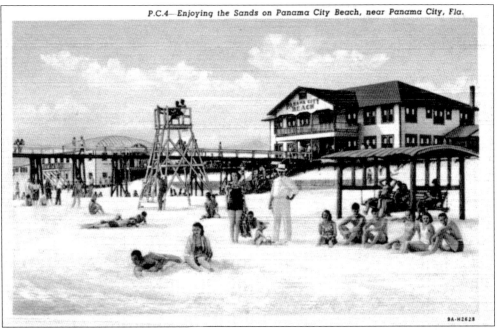

ENJOYING THE SANDS. Gideon Thomas started construction of this two-story hotel in March 1935 on 104 acres he purchased east of Long Beach. He called it the Panama City Beach Hotel, making it the original Panama City Beach hotel. He also built 30 cottages, a water tower, three windmills, and a 1,000-foot pier. It opened on May 2, 1936, and was located on what is now Thomas Drive, which was named in his honor in 1953.

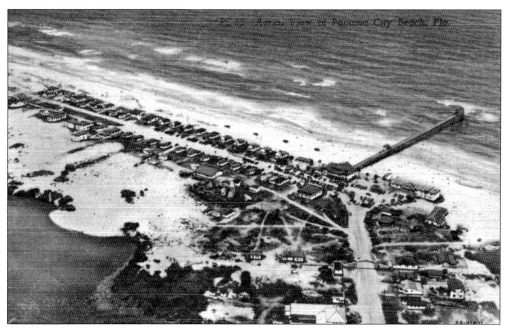

PANAMA CITY BEACH, FLA., c. 1940s. This is a great view of the layout around the Panama City Beach Hotel. The road that is now Thomas Drive had not been constructed in this postcard view. Looking at the wide road running down to the bottom of the postcard, you can see the famous arch, which had the "Welcome to Panama City Beach" sign.

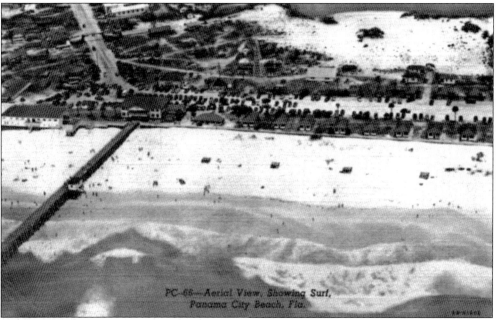

PANAMA CITY BEACH, FLA. This is another wonderful view of the Panama City Beach Hotel, looking in from the Gulf of Mexico. The "Welcome to Panama City Beach" arch is visible here also. Look closely and you can see one of the windmills. The small sand road running out to it is just about the current location of Thomas Drive. Crushed shells from Apalachicola were placed on the packed sand for the road.

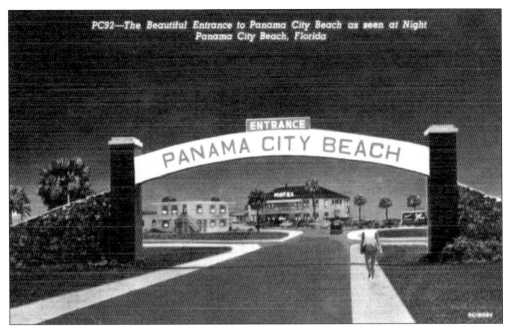

ENTRANCE TO PANAMA CITY BEACH. This is a great view of the Panama City Beach Hotel in the background, even if the postcard producer took a few creative liberties, which was not unusual. The sidewalks shown were never there, but it is a good rendering of the arch. The hotel, seen in the background, had 12 "airy" rooms on the second floor, and the ground floor had a dining room and bathhouse.

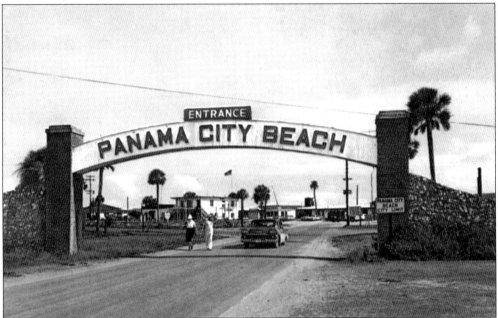

ENTRANCE TO PANAMA CITY BEACH, c. 1956. Don't let this 1956 Chevy distract you; something is missing here. Yes, it's the Panama City Beach Hotel. By 1956, it had burned. It is unfortunate that this isn't an aerial view. After Gideon Thomas died in 1937, his daughter, Claudia, and her husband, Angus W. Pledger, erected the welcome sign with the arch.

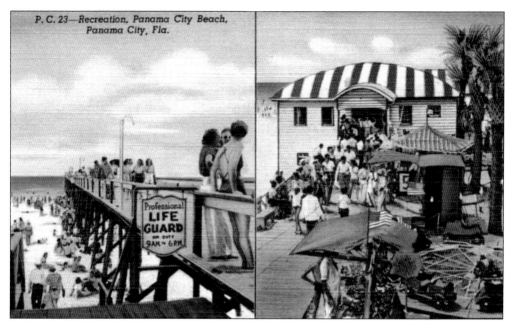

RECREATION, 1942. This multi-view postcard shows that large crowds visited the Panama City Beach Hotel. On the left is the 1,000-foot pier. Pineapple Willy's now sits on this portion of the pier at the water's edge. On the right, you see the pier continued as part of the boardwalk leading directly into the hotel. World War II was underway, and American flags are evident next to the concessions to the right.

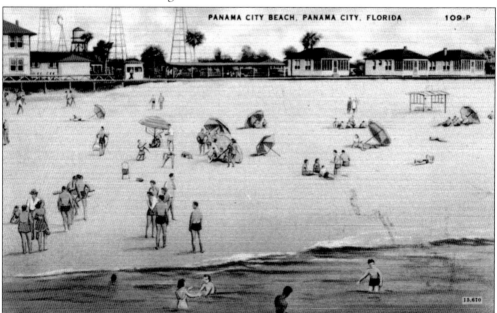

PANAMA CITY BEACH, 1946. This view illustrates that the boardwalk extended from the Panama City Beach Hotel and pier to all the cottages to the east. The water tank and the three windmills are visible in the background. One of these windmills can be seen in the view on the bottom of page 42. The cottages, seen at the right, had modern conveniences, which included electricity and sanitary drinking water.

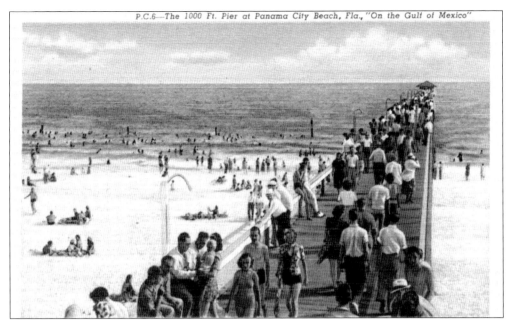

THE 1000 FT. PIER, c. 1939. The numbering code on this postcard indicates a publishing date of 1939. The pier is full of folks, and perhaps this was a Sunday evening since some of the men are wearing white shirts and ties. Like crowds of today at the beach, all manner of attire is worn. The pier had high railings with a covered pavilion at the end. In 1936, the pier had a coat of bright green and white paint.

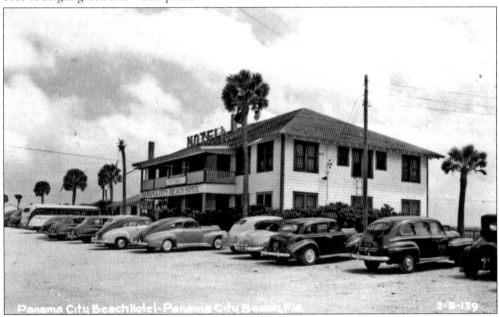

PANAMA CITY BEACH HOTEL, c. 1940. This real-photo postcard is perhaps the best view the author has seen of the Panama City Beach Hotel. Look at that old 1940s bus parked to the left of the hotel. Could this have been a bus stop? An aerial view of this scene would be nice to see. When Panama City Beach was incorporated in 1953, Claudia Pledger, the daughter of Gideon Thomas, was elected the first mayor.

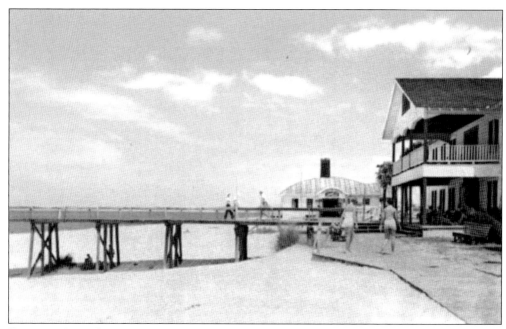

PANAMA CITY BEACH HOTEL AND RECREATION CENTER, c. 1950s. This postcard view shows the rear of the Panama City Beach Hotel with the Recreation Center in the background. It's also a nice view of the boardwalk, which extended from the Recreation Center west to the end of the row of cottages along the beach. By this time, the center of activity had shifted up to Long Beach Resort, which will be covered in the next chapter.

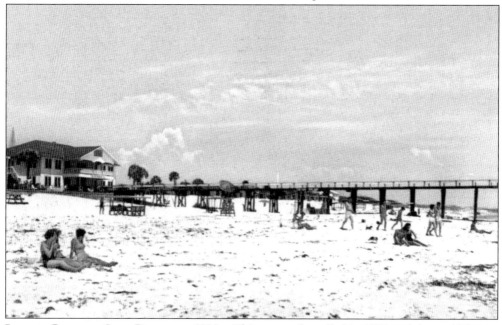

LOVELY PANAMA CITY BEACH, c. 1950s. This postcard, mailed in 1958 to Athens, Alabama, provides an imposing view of the 1,000-foot pier located behind the Panama City Beach Hotel. In 1956, during Hurricane Flossie, a barge was pushed toward the beach from 10 miles out. It rammed into this pier, and the barge was eventually beached to the east down on Thomas Drive.

Four
Long Beach Resort

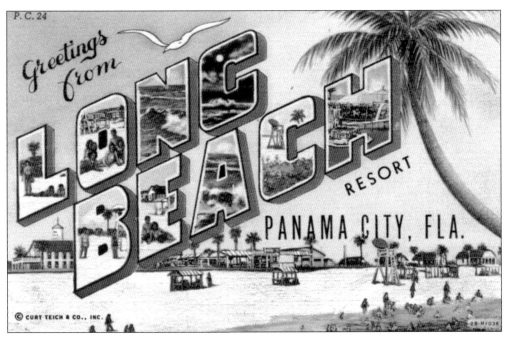

Greetings. This is a typical "Greetings" type postcard like those you would find anywhere. The scenes displayed in the lettering are actual views that appear in a particular postcard series and also in the folder that contained the same full-card views bound together for mailing. This one just happens to be the most recognizable location on the Panama City beaches, Long Beach Resort located at Long Beach.

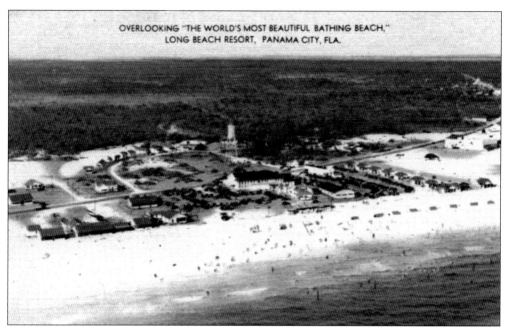

LONG BEACH RESORT, c. 1930s. When J. E. Churchwell purchased Long Beach from W. T. Sharpless and Hubert Brown in 1932 for $10,000, the beaches west of Panama City would change forever. This very early aerial view of Long Beach Resort shows the casino, water tower, some cottages, and the building close to the beach that would later become known as the Hang Out.

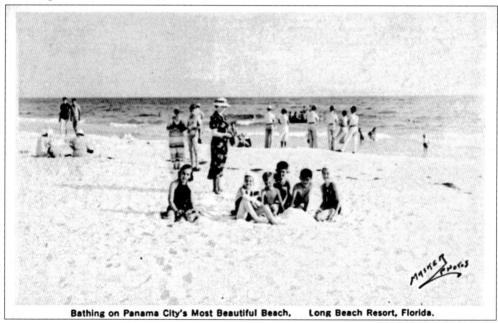

LONG BEACH RESORT. This is an early view of "bathers" on the beach at Long Beach Resort. This postcard was published by the Ashville Post Card Company in Ashville, North Carolina, using one of Edward W. Masker's wonderful early photographs. As you can see in this view, a lot of folks were just "lookers" and did not have on beach attire.

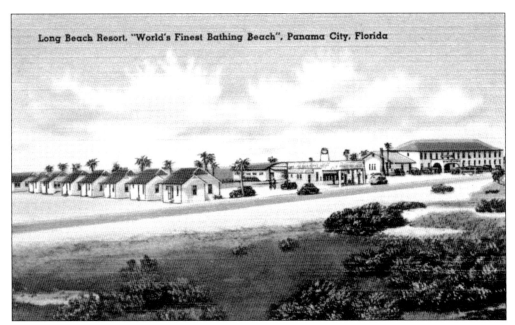

"WORLD'S FINEST BATHING BEACH." This view is from across the Coastal Highway, which would later become U.S. Highway 98 West. It shows the bungalows, a café with gas pumps, and the casino. Guy Churchwell, nephew of J. E. Churchwell, moved to Long Beach from Holmes County in the 1940s to run the casino. The photographer would have been standing to the east of the water tank, facing the Gulf of Mexico.

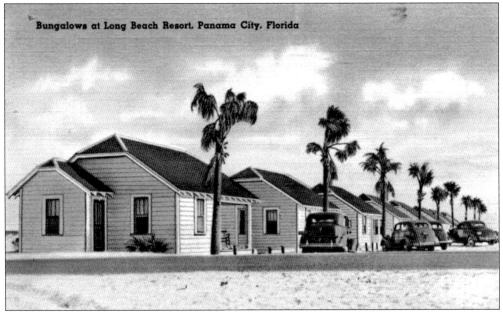

BUNGALOWS AT LONG BEACH RESORT, c. 1930s. This close-up look of the bungalows is looking from across U.S. Highway 98 West, which is in the foreground. This is the row of bungalows seen to the left on the view at the top of this page. These bungalows were taken over by the government during World War II to house workers from the Wainwright Ship Yard. Twenty-five men were assigned to each cottage.

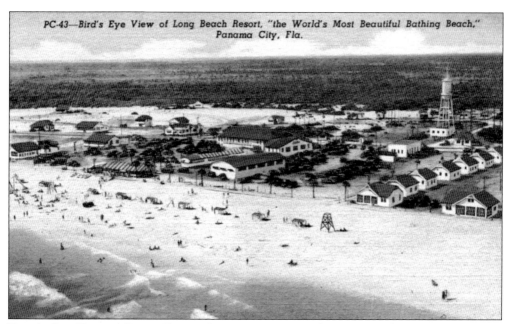

BIRD'S EYE VIEW OF LONG BEACH RESORT, c. 1940s. This 1948 aerial view of Long Beach Resort is similar to the one at the top of page 48. This postcard, another by Cooper's News Agency, was mailed from Panama City to Westfield, Massachusetts. The phrase "World's Most Beautiful Bathing Beaches" was coined by J. E. Churchwell and later shortened to "World's Most Beautiful Beaches."

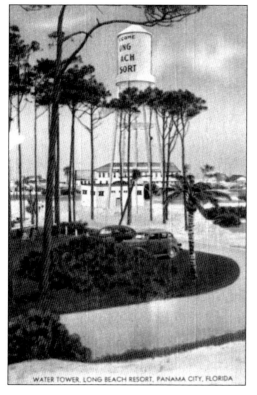

WATER TOWER. This view of Long Beach Resort is looking from the road that circled the water tank, seen in the foreground. Those two automobiles parked in the grass appear to be from the late 1930s. The building next to the water tank must have housed the artesian well and pumps to supply water to the storage tank.

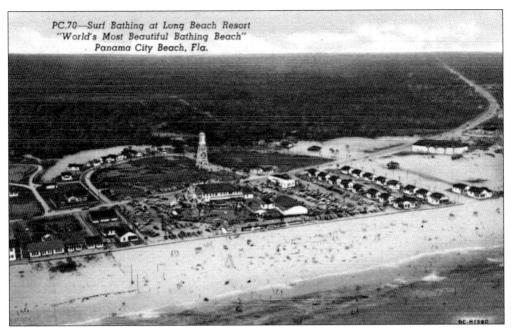

SURF BATHING, c. 1950. This 1950 aerial view of Long Beach Resort is similar to the others on previous pages; however, the Hang Out has been expanded and some amusement rides have been added at the rear of the casino, including the first Ferris wheel in town. U.S. Highway 98 West can be seen in the distance curving to the right toward the Hathaway Bridge and downtown Panama City.

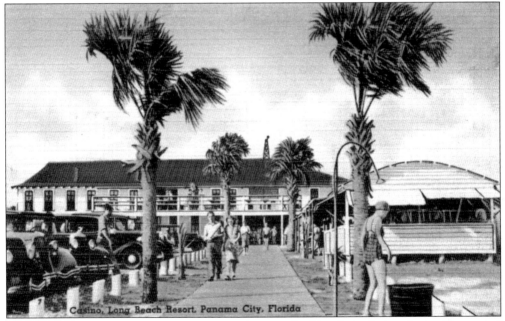

CASINO, LONG BEACH RESORT, c. 1930S. This view, looking from the beach, provides a good look at the rear of the casino. This was prior to the amusements being added there, first by John B. Davis in the 1940s and then Shan Wilcox in the 1950s. They were already advertising a café and recreational attractions to go with their bungalows.

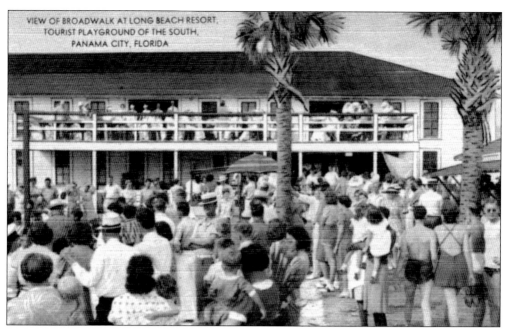

BOARDWALK AT LONG BEACH RESORT. There is apparently something going on at the Long Beach Casino today. A large crowd has gathered, although folks can be seen in swimsuits walking back and forth from the beach. During World War II, the casino was taken over by the government and served as a mess hall for military personnel.

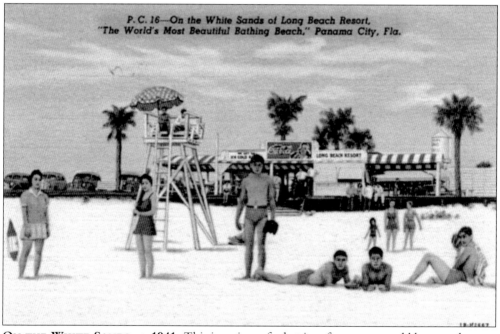

ON THE WHITE SANDS, *c.* 1941. This is a view of what in a few years would become known as the Hang Out. Built in the early 1940s, the Hang Out would be a popular gathering place until it closed in 1975. Produced in 1941, this postcard was mailed to Michigan City, Indiana. Late-1930s automobiles can be seen parked near the beach.

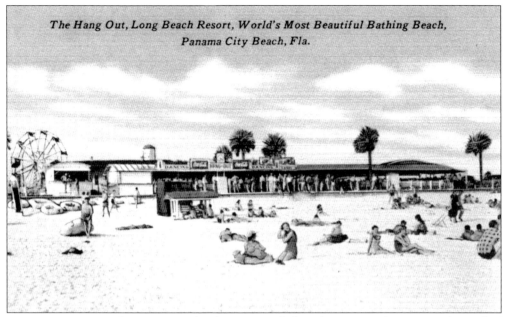

THE HANG OUT. The Hang Out has been expanded in this view and appears to be packed with dancers and watchers. It was "the place" to see and be seen. It was a sad time for many when Hurricane Eloise hit the Panhandle on September 23, 1975, and destroyed the Hang Out, along with a lot of other good memories. The casino, which was heavily damaged, would also cease operation at that time.

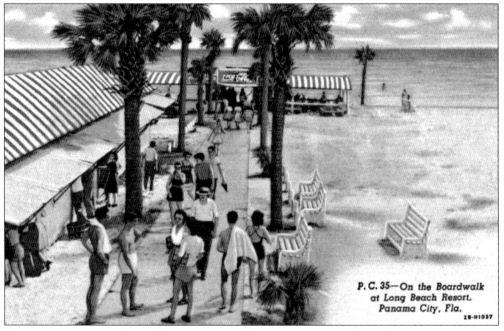

THE BOARDWALK, c. 1942. This 1942 view of the boardwalk is looking from the casino toward the Hang Out. In addition to families that vacationed there during the World War II years, many of the young men were military personnel from Tyndall Field and the Navy Operations Center. Perhaps the time they spent at Long Beach Resort helped remove thoughts of war.

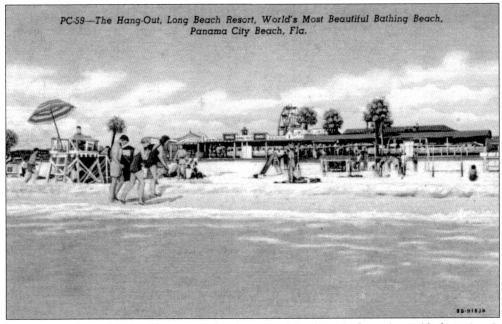

THE HANG-OUT, 1949. This view of the Hang Out is looking in from the Gulf of Mexico. It appears the photographer was standing in the surf when this picture was made. The Hang Out had been expanded and was divided into four different areas, each with its own jukebox.

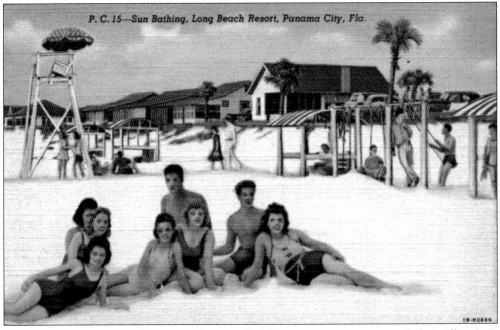

SUN BATHING, c. 1941. This postcard was mailed from a sergeant to a young lady in Illinois. It is marked "free" in the stamp box since soldiers didn't have to pay for postage during the war. The message begins mid-sentence and has "cont" written above. Apparently he wrote until a card was full and continued on another.

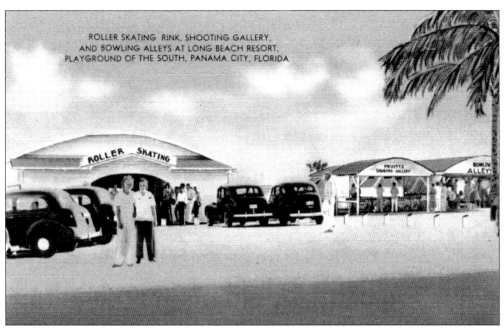

Playground of the South, c. 1930s. The 1930s automobiles, parked near some of the attractions at Long Beach Resort, help date this postcard view. The skating rink, shooting gallery, and bowling alley were located east of the casino. The bowling alley, which was right next to the boardwalk behind the casino, was later converted into concessions.

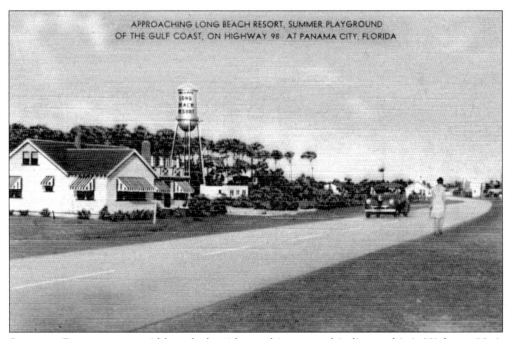

Summer Playground. Although the title on this postcard indicates this is Highway 98, it actually is the road that circled around the water tank. As mentioned earlier, many postcards were altered by the printer. The "green grass" has been painted in, and that road was never paved, so the middle stripe down the road was also added.

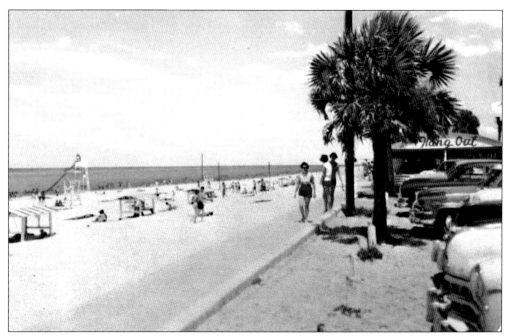

SURF, SNOW, WHITE SAND, AND SUNSHINE. This early-1950s view shows the parking lot at the east end of the Hang Out. This parking lot was actually quite large and separated the casino and the Hang Out from the cottages to the east. The Hang Out was painted white with bright-red lettering and trim.

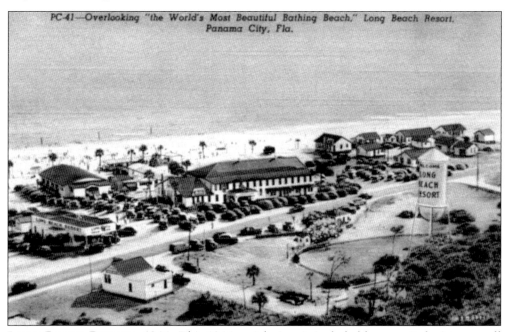

LONG BEACH RESORT, 1946. This 1946 aerial view is included because it depicts a small miniature-train ride at the foot of the water tank. In a few years, on this same site, this little train would "grow" to become Petticoat Junction with real full-size steam locomotives. It would transport passengers from the train station there to the famous and popular Ghost Town.

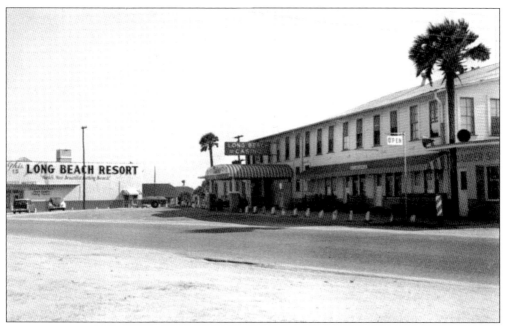

LONG BEACH RESORT. This is the best postcard view the author has of the front of the Long Beach Casino. To the left of the casino entrance, you can see the Long Beach Resort grocery store and gas station. And on the right is the barbershop. There is a picture on the author's web site (www.jdweeks.com) of Guy Churchwell standing across the road as the casino building burned the day it was torn down.

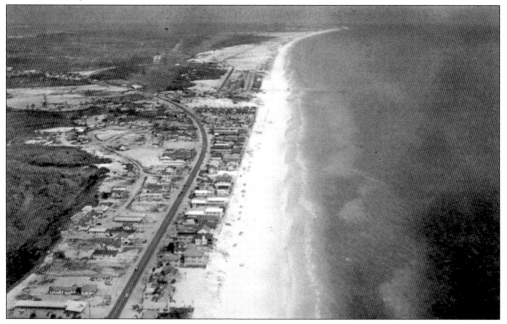

PANAMA CITY BEACHES, *c.* 1950s. This is one of the last good aerial views of Long Beach Resort with the old water tank, which was replaced by a modern version (see next page). A magnifying glass may be necessary. Down the beach in the distance is the 1,000-foot pier that was behind the old Panama City Beach Hotel.

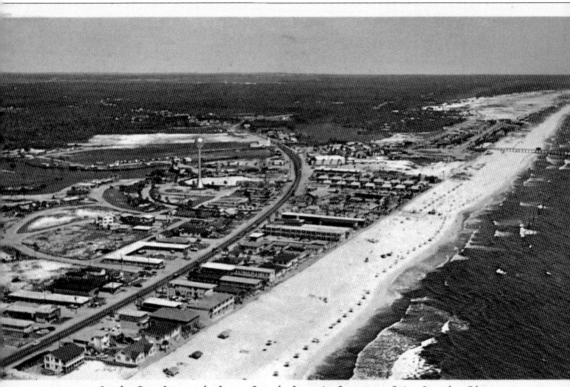

Bird's Eye View of Long Beach Resort, Panama City Beach, Fla.

LONG BEACH RESORT, 1966. Let's take one last look at this aerial view of Long Beach Resort before we move on. A new modern water tank has been added, and looking down the beach, it appears that everyone there has rented a beach umbrella from E.B.S. (Ed's Beach Service). A little farther down the beach, the old 1,000-foot pier is still in place, and Thomas Drive is still pretty much unspoiled. Guy Churchwell, who managed the Long Beach Resort Casino, was the mayor of Long Beach at this time and continued in that office until Long Beach was incorporated into the city of Panama City Beach in 1970. The sandy looking area at the top of the water tank is now the site of a Wal-Mart Super Center. You can tell by looking at Lake Flora that the Kona Kai has not yet been built. This postcard was mailed from Panama City to Little Rock, Arkansas.

Five

THOMAS DRIVE

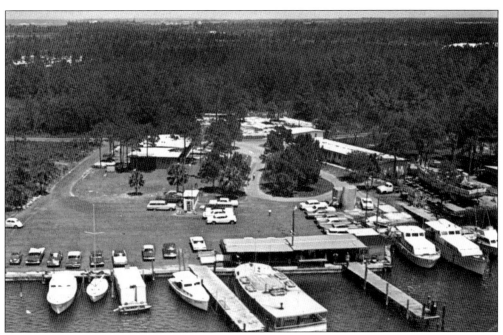

TOM-RIC MOTEL. The Tom-Ric Motel and Marina was located at 5323 North Lagoon Drive, behind Captain Anderson's Restaurant. They provided rooms and apartments as well as deep-sea fishing and charter boats. The owner was Tom Corley. The motels and apartments are now gone and have been replaced with the much larger Lighthouse Marina. This aerial view was photographed by John Reaver, who owned the Reaver Air Service. Reaver also owned the Skyland Airport, which was located in St. Andrews near the old Lisenby Hospital.

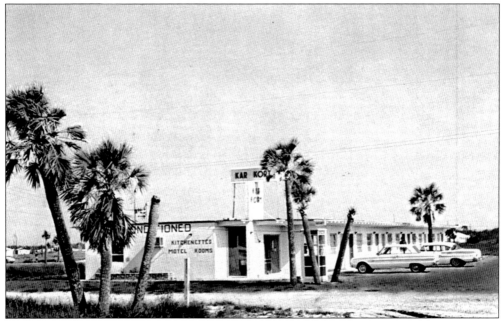

KAR KORT MOTEL, c. 1960. This small neat motel was located on Thomas Drive next to Captain Avenue and two blocks south of Treasure Island Marina, near where the Treasure Ship Restaurant now sits. It later became the Ship Shape Inn Motel. Only the ruins of the still-standing walls remain, and it is surely destined to join the long list of forgotten memories.

SUN-GLO MOTEL, c. 1960. The Sun-Glo Motel was located at 5401 Thomas Drive, overlooking the Gulf of Mexico. It had rooms and apartments, a pool, a playground, and television. The owner and mangers were Bud and Fran Hastings. There appears to be a shortage of chairs, with only two inside the fence. There is, however, a picnic table with umbrella outside the fence and a sun deck up on the second level.

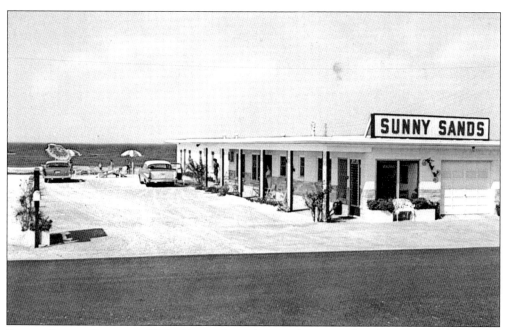

SUNNY SANDS COURT, c. 1950s. Located on what was then part of Surf Drive, the Sunny Sands Court was one block off Thomas Drive. Featuring the standard amenities of small one-story beachfront motels, it also had efficiency apartments with kitchenettes. What a lovely location it must have been to enjoy the leisurely pace of the 1950s.

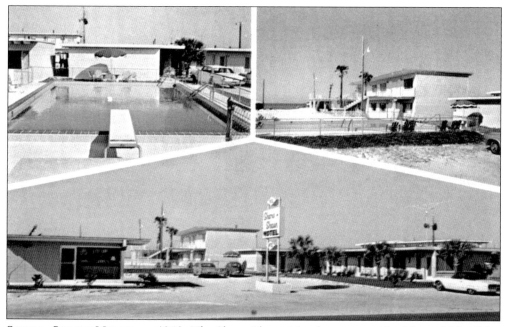

SHARO-SHAUN MOTEL, c. 1960. The Sharo-Shaun Motel was owned by Mr. and Mrs. John Junius Hays. Located 100 feet from the Gulf, it had a pool, playground, swings, and a grill. The buildings were painted a bright pink and aqua. This motel was replaced by the Sunshine Shores Condominiums.

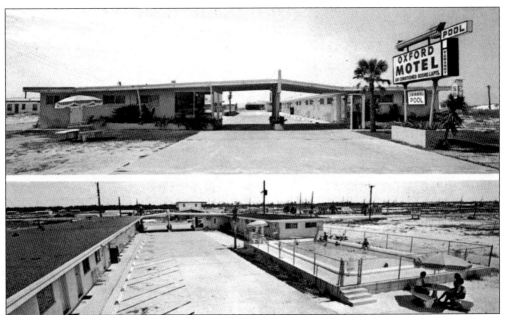

OXFORD MOTEL, c. 1960. The Oxford Motel, although fronting Thomas Drive, had an address listed as 5614 Gulf Drive, the road between the motel and the beach. Fifty years ago, the owners were V. O. Pitts and O. H. Whitehurst. This postcard was published by Artcraft Studio, located in downtown Panama City. Now with a second story added and the pool filled in to make more parking room, the current name is the Desert Palms.

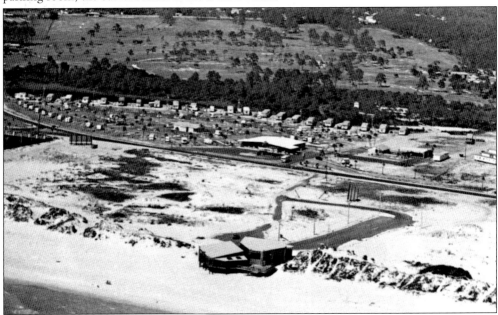

PLEDGER'S CAMPER INN. Pledger's Camper Inn, developed and opened in 1969 by Dennis Pledger, was located at 8800 Thomas Drive near the Signal Hill Golf Course. This land, including the golf course, which is leased to the Sherman family, is part of the old Panama City Beach Hotel property developed by Gideon Thomas in 1937. The camping property is now the Panama City Beach KOA.

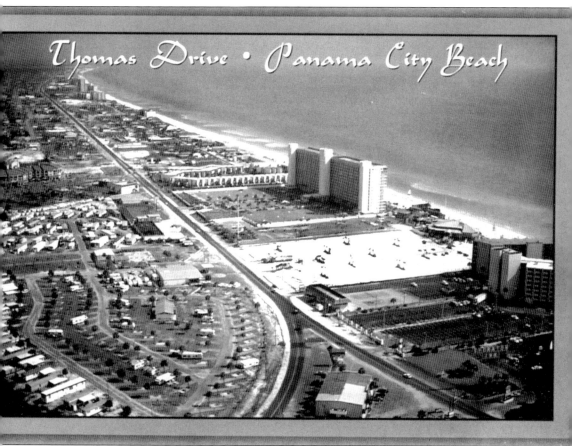

THOMAS DRIVE, c. 1990s. This early-1990s aerial view of Thomas Drive illustrates the drastic changes that have taken place since the condo explosion started in the early 1970s. Club La Vela and Spinnaker's can be seen on the right with the large parking lot. On the left is the Panama City KOA, formerly Pledger's Camper Inn (compare to the bottom of the previous page). Thomas Drive splits here, seen in foreground, and to the left is North Thomas Drive, which goes up by the Signal Hill Golf Club. To the right is South Thomas Drive, which goes west toward Pineapple Willy's. This aerial photograph was taken by Tim Allen prior to Hurricane Opal in October 1995. Opal damaged a lot of the older structures, which fueled even more new development. Although condominium growth on Thomas Drive has been slower than on Front Beach Road, it is really picking up speed.

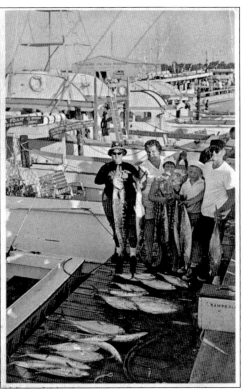

A DAY'S CATCH, 1964. The Treasure Island Marina is where the Treasure Ship Restaurant is "docked," on South Grand Lagoon. It looks like this group did very well on their fishing trip. This postcard was mailed on June 10, 1964, from Panama City to Fort Payne, Alabama. Treasure Island Marina is also the home for the popular "Pirate Ship" that patrols up and down the beach firing its cannon.

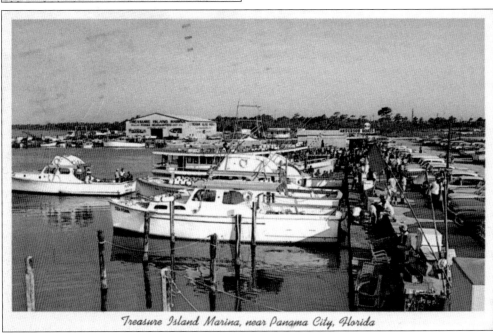

TREASURE ISLAND MARINA, 1963. This nice view of Treasure Island Marina actually shows the marina building in the background. This postcard, mailed July 23, 1963, was sent to Jonesboro, Georgia. The writer relates they had a safe trip down, and there had been a bad storm on Sunday when they arrived.

SUN-N-SWIM MOTEL. The Sun-N-Swim Motel was located at 7709 Surf Drive, just off Thomas Drive toward the beach. They advertised that each unit overlooked the beach with fully equipped kitchenettes with patio or private balcony. This postcard was mailed from Panama City to Tulsa, Oklahoma, and the writer, obviously a jokester, is saying he arrived OK and that they can have fun, since he is not there to bother them.

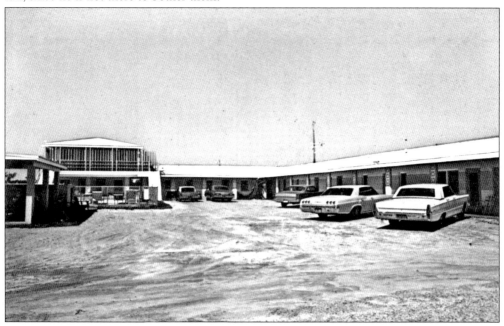

JOLLY JILL MOTEL. The Jolly Jill Motel was owned by Jewel and Johnson Usry and was at 7816 Surf Drive, one block off Thomas Drive toward the beach. With extensive modification it is now the Surf N Sand Condominiums. On this postcard, published by Elmo W. McCormack, they boasted about being "On the Miracle Strip;" however, they may have been considered a little removed from the "Miracle Strip."

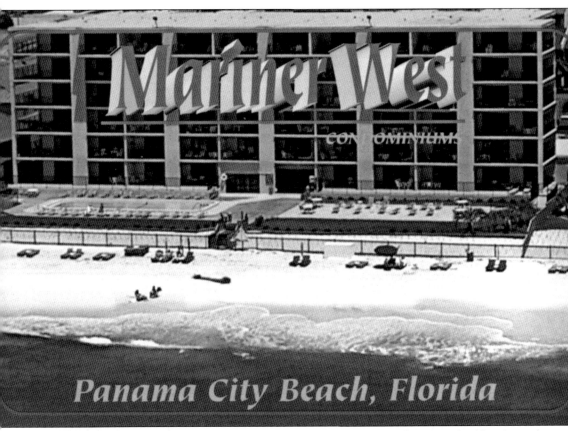

MARINER WEST CONDOMINIUMS. The Mariner West, a six-story condominium building located on Thomas Drive, is where the author spent a great deal of time the last two years doing research for this book. The spring and fall were best for both talking to people and driving around to search for the locations of some of those places that have disappeared. Summer traffic is much too congested for that kind of activity. Compared to other condominiums in the area, Mariner West is relatively small. A large number of the units are owner-occupied, so it has a homier atmosphere. The author and his grandchildren were there last summer to visit the Miracle Strip Amusement Park one last time before it closed. The children seemed to enjoy hearing about the times their parents made their first trip to the beach at Panama City and went to the very same Miracle Strip Amusement Park.

Six

BEACH MOTELS AND COTTAGES

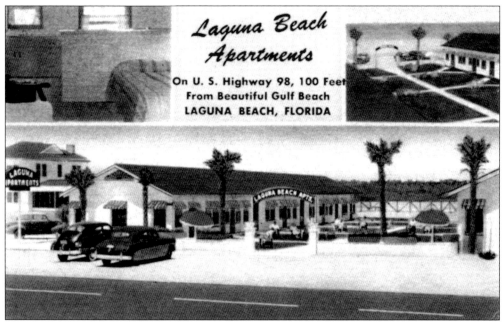

LAGUNA BEACH APARTMENTS, c. 1940. This view of the Laguna Beach Apartments is typical of those that sprang up at Laguna Beach starting in the late 1930s. J. B. Lahan from Birmingham, Alabama, purchased property in that area in 1936 and built a home. He sold off some of his property in lots for vacation cottages, and that was the beginning of Laguna Beach. Many folks, the author included, had their first taste of those beautiful white-sand beaches here at Laguna Beach. This one, being directly on Highway 98 West, boasts of being 100 feet from the beautiful Gulf Beach. All motels listed in this chapter will be on U.S. Highway 98 West.

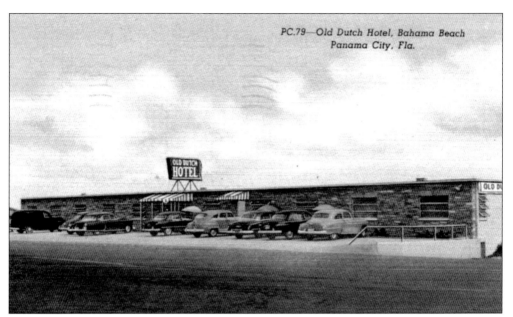

OLD DUTCH HOTEL, c. 1952. The Old Dutch Hotel was located on Bahama Beach, an area developed by Cliff Stiles of Birmingham that was earlier called Dutchville. This postcard was mailed to Youngstown, Ohio, in 1953, encouraging someone to "come on down and visit." The Old Dutch Tavern, the first bar on the beach, was next door. Located on that site now is the Days Inn Beach.

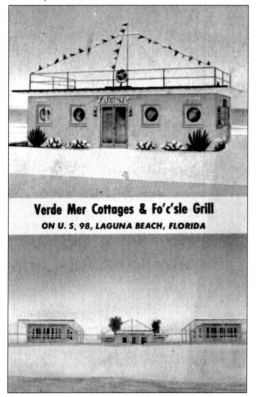

VERDE MER COTTAGES AND FO'C'SLE GRILL. The Verde Mer, operated by Claude Maenza, sat directly on the beach side of Highway 98 in Laguna Beach. They advertised fine food and modern cottages. No one seems to recall the Fo'c'sle Grill, and since it does appear to be quite small, it could easily have been overlooked. The sender of this postcard says they ate there last Sunday at noon. Hopefully there was not a large crowd.

Scene Showing the Apartments and the World's Most Beautiful Beach

EDGEWATER GULF BEACH APARTMENTS, c. 1940s. The Edgewater Gulf Beach Apartments were located at Edgewater Gulf Beach. They contained one and two bedrooms, a combination living/dining room, kitchen, and a full bath. As the arrow sign indicates, the daily rate was $2 per person. Edgewater Beach Resort, incorporated in 1953, merged with Panama City Beach in 1970. This postcard message says the sender would not want to stay here since there is nothing but sand.

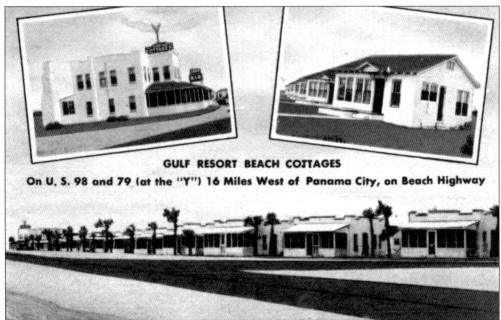

GULF RESORT BEACH COTTAGES
On U. S. 98 and 79 (at the "Y") 16 Miles West of Panama City, on Beach Highway

GULF RESORT BEACH COTTAGES. The Gulf Beach Resort area was developed by J. B. Lahan and W. E. Hooper, both of Birmingham. The Gulf Resort Beach Cottages, located at the intersection of State Highway 79 and U.S. Highway 98, were owned by the Arnold Brothers. The cottages had two bedrooms, a living room, and kitchen.

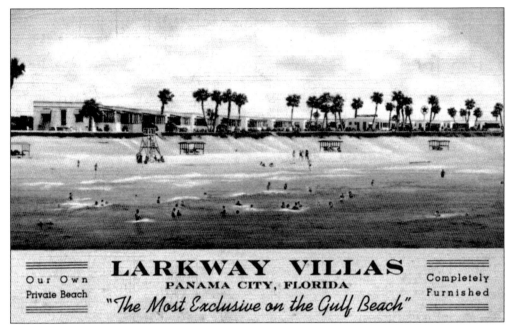

LARKWAY VILLAS, *c.* 1940. The Larkway Villas were built in 1938 and owned by Harry Edwards and his son, Jimmy Lark. They consisted of 17 individual four-room Spanish-type buildings. In 1948, when this postcard was mailed to Aliceville, Alabama, the owner was listed as M. H. Edwards Jr. and the manager as D. M. Powell. Edwards was a real estate broker and had a connecting office.

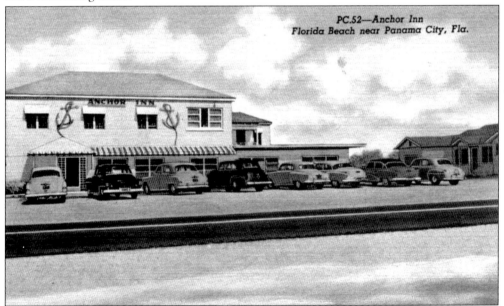

ANCHOR INN, *c.* 1950. The Anchor Inn was located at 14400 West Highway 98 and was owned by Mr. and Mrs. George F. Godwin. This postcard, another by Cooper's News Agency, was mailed on June 18, 1954, to Louisville, Kentucky. The writer relates that she had a marvelous meal here tonight. It was directly across the road from the current location of the Fontainebleau Terrace Motel.

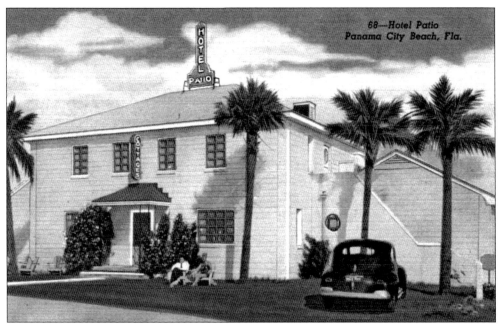

HOTEL PATIO, c. 1940. The Hotel Patio and Cottages were east of the Panama City Beach Hotel near Oleander Court and McElvey Cottages. Opened and operated by Mrs. J. W. Crawford, they offered modern air-conditioned cottages with private baths. In 1953, the resident manager was Mrs. C. A. Attwood. The man with the white shirt and tie and the woman in a bathing suit sitting together out front are apparently posed for this photograph.

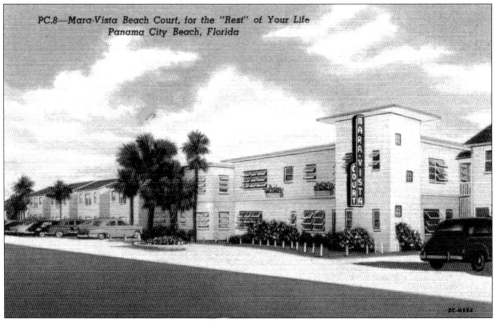

MARA VISTA BEACH COURT, c. 1950. The Mara Vista was located at Mara Vista Beach, west of the Fontainebleau Terrace between Russell Court and the Anchor Restaurant. It was owned and managed by George C. Cowgill Jr., who was from Birmingham. It advertised that they catered to family groups and had a private beach as well as a special children's beach.

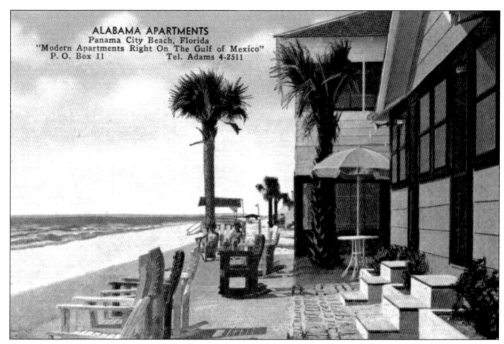

ALABAMA APARTMENTS. The Alabama Court Apartments, as it was known, was right next to Long Beach Resort on the west side. Owned and operated by Charlie and Marion Collins, it advertised accommodations for 2 to 10 people with shopping center, amusement park, restaurants, and Long Beach Casino at your doorstep.

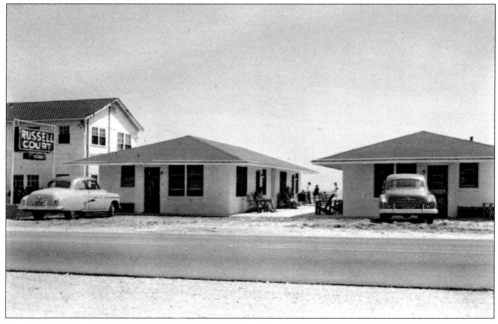

RUSSELL COURT, 1950S. Russell Court was located at Mara Vista Beach close to the Mara Vista Beach Court. They advertised a new and modern facility, with or without a kitchen, overlooking the Gulf. They mentioned a modern café nearby, which would be the Anchor Restaurant. This postcard was published by Robertson Photo Service in Panama City, Florida.

RIPTIDE MOTEL AND APARTMENTS, c. 1950s. The Riptide Motel was located on Bahama Beach west of the Old Dutch Tavern. The owners were Mr. and Mrs. H. B. George. This postcard, published in Charlotte, North Carolina, was sent from Panama City to Buffalo, New York. The author says he has no fish stories to tell but has some real dillies about the species of mermaids peculiar to this clime.

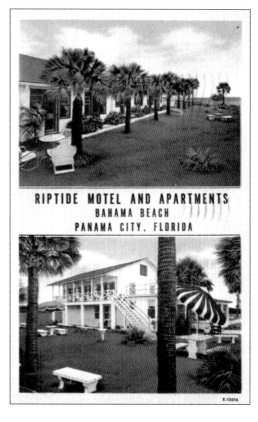

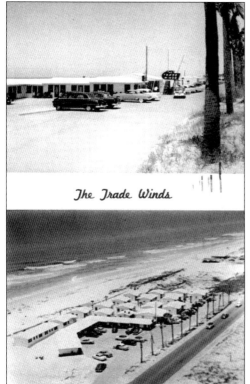

THE TRADE WINDS, c. 1950s. The Trade Winds Motel was on Gulf Beach, just before you get to Bahama Beach traveling west on Highway 98. It was owned by the Schilleci family. This postcard, mailed to Illinois in 1956, was published by David Robertson in Panama City. The sender says, "We are at Panama City right down by the Gulf where you can hear the waves rolling."

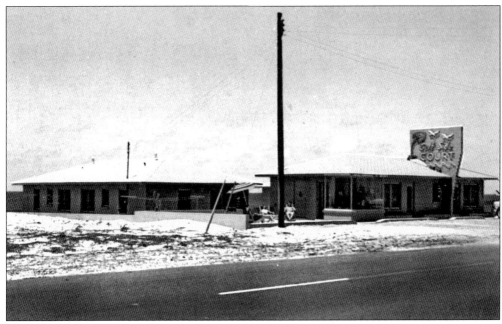

GULF SIDE COURT. The Gulf Side Court was located about 20 miles west of Panama City at Sunnyside, which had been homesteaded and developed by M. E. McCorquodale in 1936. This is an unmailed postcard, also by David Robertson. The Gulf Side Court advertised they were open all year-round and had automatic heat with motel rooms, efficiencies, and two-bedroom cottages.

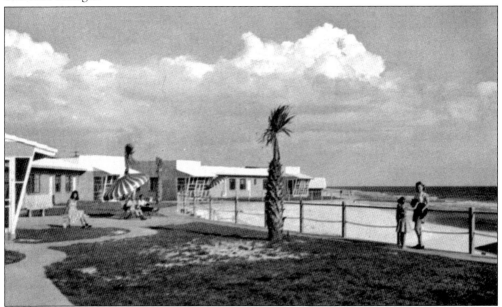

PALMETTO HOTEL COURT, 1949. Located at the intersection of Highway 79 and U.S. 98, the Palmetto Hotel Court was right on the beach, directly across the highway from the Gulf Resort Beach Cottages (see page 69). Built in 1948 by Dick Arnold, their 31 units all had a telephone, circulating hot water, and daily, weekly, or seasonal rates. The Palmetto was the first true motel built in Bay County.

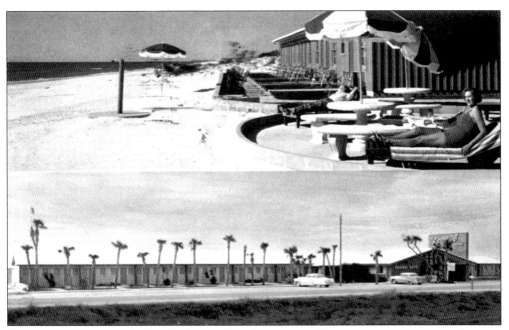

THE ESCAPE MOTEL, 1958. The Escape Motel was west of Long Beach Resort just before you get to Edgewater Beach and was owned by Mr. and Mrs. Dick Arnold. That looks like a 1955 Oldsmobile and a 1954 Pontiac out front. And look at all that open beach only a little ways from Long Beach Resort. Sadly the Escape was destroyed by Hurricane Eloise in 1975.

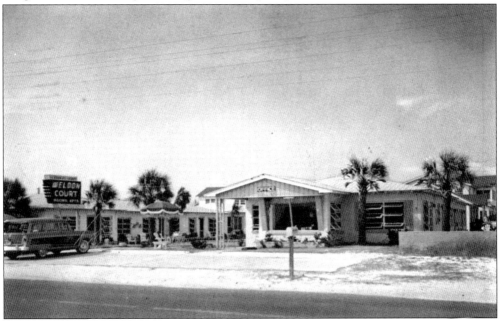

WELDON COURT, 1958. Weldon Court, located at Laguna Beach, had large efficiencies, one- and two-bedroom apartments, and three-bedroom cottages. Sitting right on the beach, they advertised summer and winter rates. The sender of this postcard was there in February and tells the recipient in Pennsylvania that the forecast for tonight is 28 degrees. They had driven over 8,000 miles and had only had a little speedometer trouble.

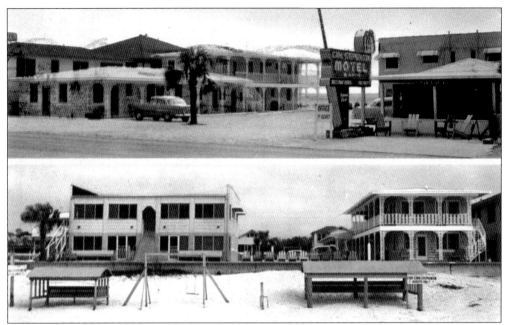

CARL STEPHENSON MOTEL, 1958. This motel was located on Long Beach next to the Barney Gray Motel and Apartments. It advertised being directly on the beach with one- and two-bedroom apartments under the personal supervision of the owner, Carl Stephenson. This postcard was mailed from Troy, Alabama, to Philadelphia on January 31, 1958. The senders most likely were on the way back home to Pennsylvania.

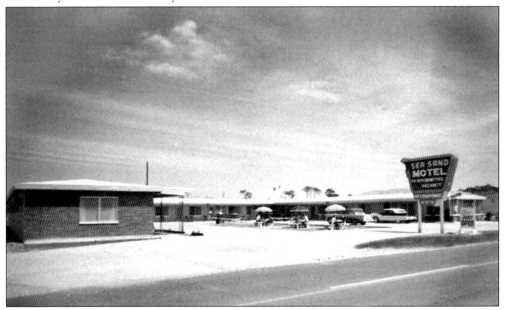

SEA SAND MOTEL, 1957. The Sea Sand Motel was one block west of Long Beach Casino. Owned and operated by Mr. and Mrs. Guy T. Easterling, they were open year-round and had motel rooms and one- and two-bedroom apartments with kitchenettes. The senders mailed this postcard to Bessemer, Alabama, and related the brief message that they arrived in a storm last night, went crabbing this morning, and "wish you were here."

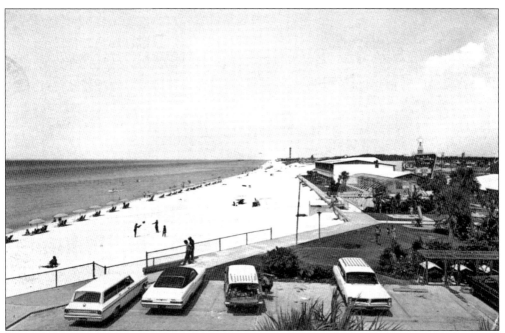

HOLIDAY INN #3, 1968. Holiday Inn was the first large motel chain to come to Panama City. This was the third one built, as the number implies, and was located between the Miracle Strip Amusement Park and Petticoat Junction. Today, with modification and enlargement, it is the Holiday Inn Sun Spree Resort. This postcard was mailed to Indiana on April 12, 1968.

SAL'S COURT, 1960. Sal's Court, owned and operated by Ed C. Kramer at Laguna Beach, was in fact renamed Kramer Court and then the Impala Motel. This postcard, most likely picked up on a Panama City vacation trip, was mailed from Birmingham, Alabama, on June 16, 1960, to *The Price is Right* in New York City. The sender was making a guess for the value of the Gift Showcase, which was $16,350.32.

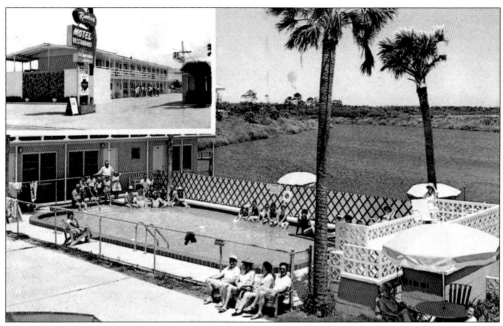

RIVIERA MOTEL AND RESTAURANT. The Riviera Motel, owned by Wyatt and Robbie Herring, was located at Sunnyside Beach. This postcard, published by Alex's Studio in Panama City, stated they had one- and two-bedroom and efficiency apartments. Although located across Highway 98 from the beach, you can see they were situated on one of the many small lakes and bodies of water that are all up and down the beach.

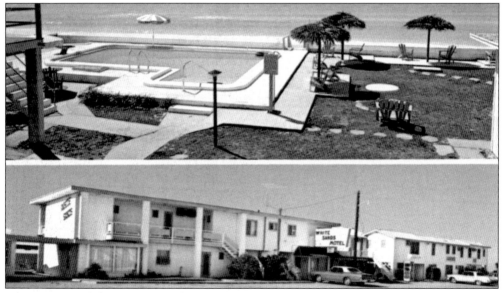

WHITE SANDS MOTEL, 1975. The White Sands Motel was located at Laguna Beach next to Kramer Court. It advertises a clean attractive restaurant located across the street. This postcard was mailed on January 25, 1975, by a Boy Scout in Birmingham to the Think and Grin Department of *Boy's Life Magazine*, which solicits jokes from Boy Scouts. His entry asks the old joke about "What's green, has 4 black eyes, 3 legs, and 5 arms?" The answer is, "I don't know either, but it's following us!"

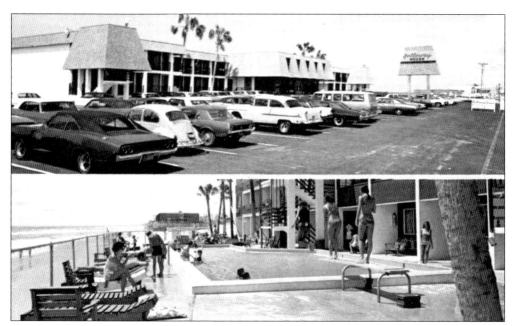

HOLLOWAY HOUSE. The Holloway House was located on Mara Vista Beach at 15405 West Highway 98. It was owned by John Holloway from Geneva, Alabama. It is now called Beachbreak by the Sea. This postcard was mailed to Massachusetts; the sender says the weather is nice now and suggests that the recipient write to Mr. Holloway about her accident. It's too bad we can't hear a little more about that accident.

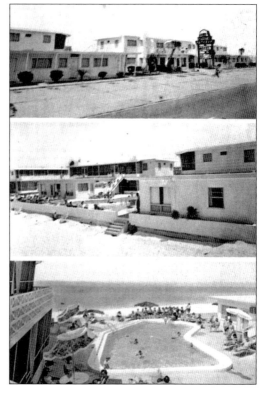

SOUTH PACIFIC MOTEL. The South Pacific was located at Wayside Beach just west of the Holloway House (above). The motel had rooms, apartments, and cottages with many amenities including Hi-Fi music, maid service, rocking chairs, and a lifeguard. The sender of this postcard marked an X on the front indicating their room and that they were paying $80 a month with the linens furnished. The South Pacific is still operating.

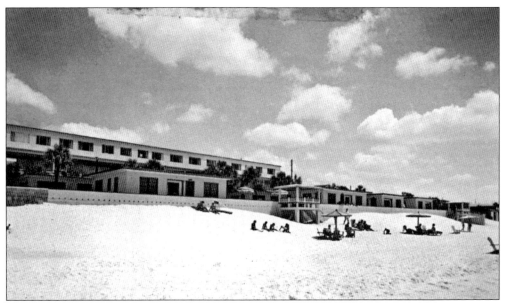

WAVE CREST COURT. The Wave Crest was located at Sunnyside, just past Laguna Beach and one mile from Philips Inlet to the west. The company also owned the Kiska Court, across Highway 98, which consisted of two-bedroom cottages with living rooms, kitchens, and a bath. Both had a pool. Everything was bulldozed several years ago, but no new construction had begun as of the summer of 2005.

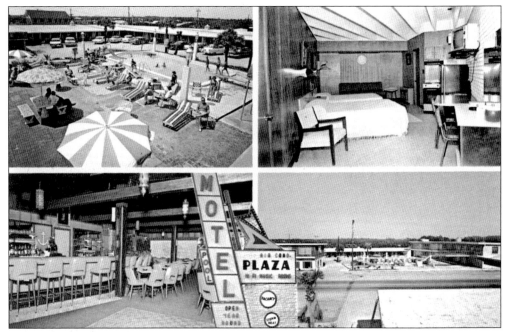

THE PLAZA MOTEL. The Plaza Motel was near the Old Dutch at Bahama Beach and within walking distance to the Miracle Strip Amusement Park. Owned by Mr. and Mrs. D. R. Meadows, it was headquarters for the annual Pratt City Fraternal Order of Eagles deep-sea fishing trip. The Plaza advertised as the "Friendly Family Motel" with 41 units, efficiency kitchens, steam heat, and a nursery.

FUN 'N SAND MOTEL, *c.* **1950s.** The Fun 'N Sand Motel was located west of the "Y" (where State Highway 79 intersects Front Beach Road) at Gulf Resort Beach, near Laguna Beach. Built in the 1950s, they had 29 units that were air conditioned, had steam heat, tubs and showers, and foam rubber mattresses. They had no televisions in the rooms but did have a television lounge.

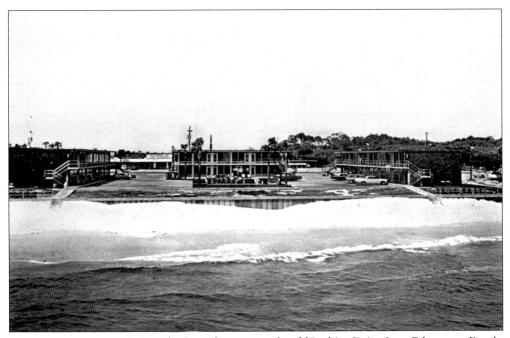

SUNTIDE MOTEL, *c.* **1960s.** The Suntide was near the old Jenkins Drive In at Edgewater Beach. It was a rather large complex with 58 deluxe units. The owners-managers were Mr. and Mrs. Jack Hutto, and they indicated they were near a public fishing pier (the County Pier) and an amusement park (Miracle Strip Amusement Park).

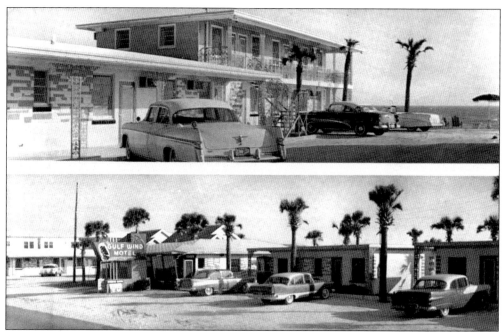

GULF WIND MOTEL, c. 1950s. The Gulf Wind Motel, located at Long Beach between the Holiday Inn #3 and the Barney Gray Motel, was owned and operated by Mr. and Mrs. S. J. Boutwell. They had 31 new and modern units that included rooms, kitchenettes, and apartments. Notice how close to Highway 98, in the foreground left corner, the buildings are situated.

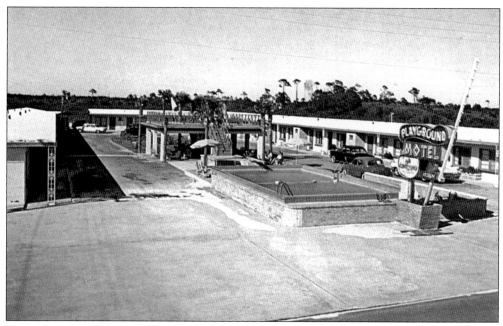

PLAYGROUND MOTEL, c. 1960. The Playground Motel was up at Wayside Beach near the Wayside Drive In Theatre and the Wayside Park. Owned by Mr. and Mrs. D. L. Minor, it had one- and two-bedroom apartments facing the Gulf of Mexico but across Highway 98 from the beach. Most motels across from the beach still had unobstructed views of the Gulf.

SHELBY'S COURT. Shelby's Court, owned by Shelby Boutwell, was just west of the Larkway Villas at Florida Beach and on the east side of the Anchor Inn Restaurant. It was small, with only 14 units, but it sported both shower and tub tile baths. Shelby's Court was opened year-round, as most were, and had special monthly and weekly winter rates.

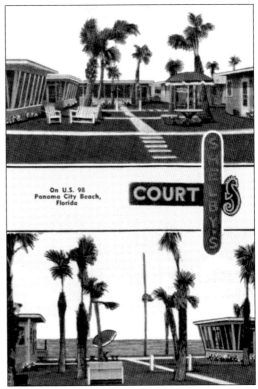

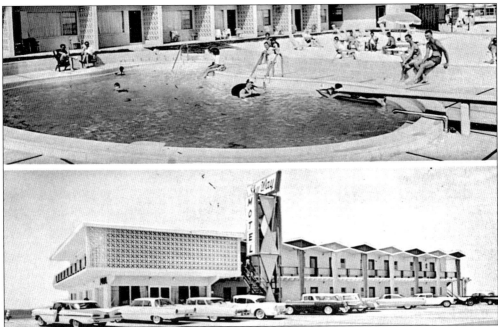

SKY WAY MOTEL, c. 1950s. The Sky Way Motel was located at El Centro Beach just east of the "Y" and west of the South Pacific Motel, which is still there and one of the few that have the same old recognizable signs that visitors from the past remember. It was directly on the beach and had good restaurants across Highway 98.

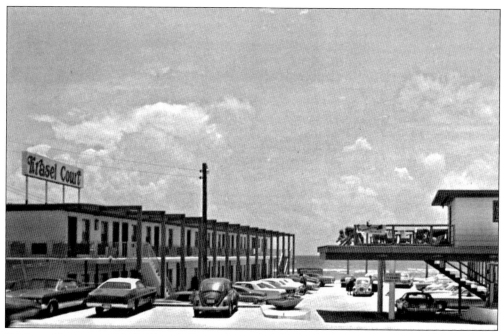

KRASEL COURT, c. 1960. Krasel Court, located right in the heart of Long Beach and across the street from the Long Beach Restaurant, featured deluxe studios with spacious living room and kitchen combination. It also had cottages and motel rooms. Sitting right on the beach, it was a short walk down to the famous Hang Out. This postcard was published and distributed by Bob Sharpe in Panama City.

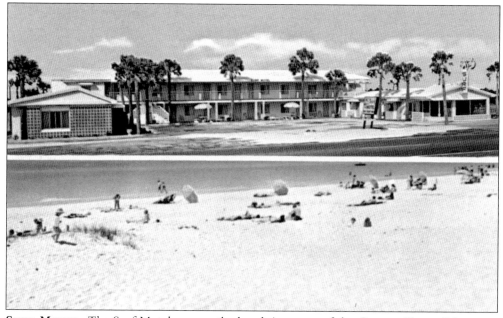

SURF MOTEL. The Surf Motel was on the beach just west of the County Pier at Edgewater Beach and near the Miracle Strip Amusement Park and Goofy Golf. It was a very nice place to stay and was only a 10- or 15-minute walk down the beach to Long Beach Resort Casino and the Hang Out.

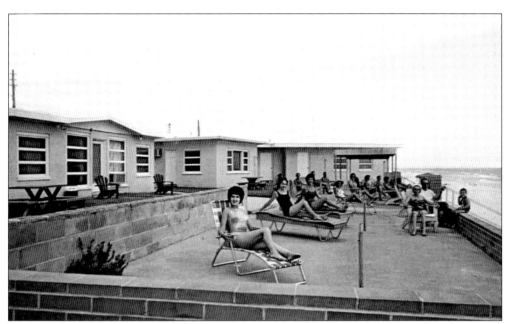

IMPALA MOTEL. You may recognize this view of the Impala Motel from page 77, since it was the old Sal's Court. Now it is the Impala Motel, still owned by Ed C. Kramer, and the color of the building has changed from green to yellow. The back of this postcard is exactly like the one of Sal's Court except now instead of being in Panama City Beach it is in West Panama City Beach.

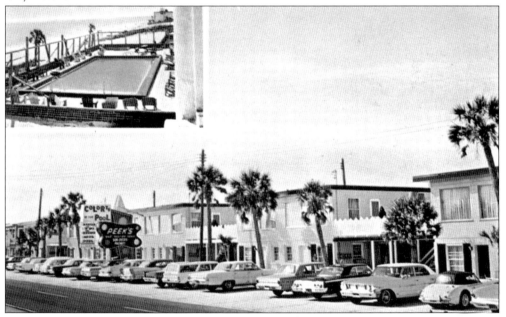

PEEK'S BEACH APARTMENTS, c. 1970. Peek's was located at Florida Beach between the Fontainebleau Terrace, which is still there, and the Tourway Inn, which is long gone. They were a family-oriented business and sat directly on the beach. Advertising a Gulf view, they had one- and two-bedroom apartments and efficiencies with kitchenettes. You can see from their sign out front that they also had color television and a pool.

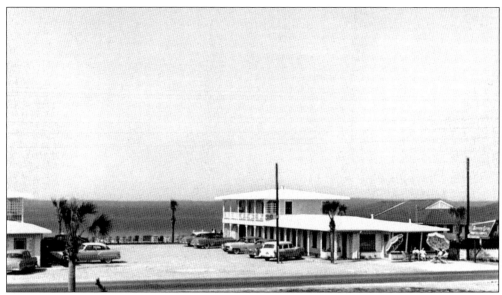

BARNEY GRAY MOTEL, c. 1950s. The Barney Gray was built by Barney Gray, who also developed the Miracle Strip Motel. Located on Long Beach, it was east of the Gulf Wind Motel and the Holiday Inn #3. It only had 15 units, which included furnished motel rooms and apartments. The name later changed to the Majestic Motel and eventually gave way to a huge condominium complex called Majestic Towers.

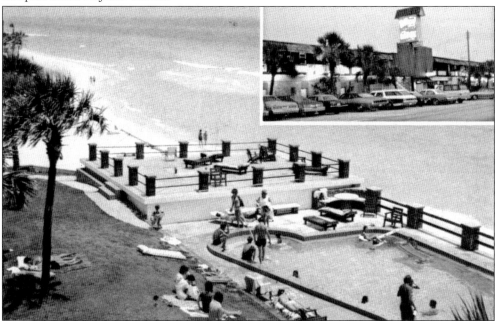

DRIFTWOOD LODGE, c. 1970s. The Driftwood Lodge, owned then by Doug and Lorraine Gilmore, is directly on the beach at Wayside Beach. It was originally built in 1955 by Ted Alford, who also developed the Beachcomber Motel (on next page). The Driftwood Lodge was a two-story building with 12 units. It featured a swimming pool and sundeck right on the Gulf. It is also one of the few that still remain, as the majority of all these motels and cottages are now gone.

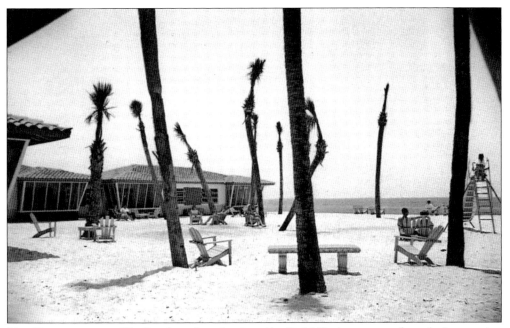

THE BEACHCOMBER. The Beachcomber, developed by Ted Alford, was across from the intersection of Highway 79 and U.S. Highway 98, directly on the beach. It had 14 new and modern one- and two-bedroom units that featured living room, dinette, electric kitchen, tile bath, and screened porches. Opened year-round, it was both heated and air cooled.

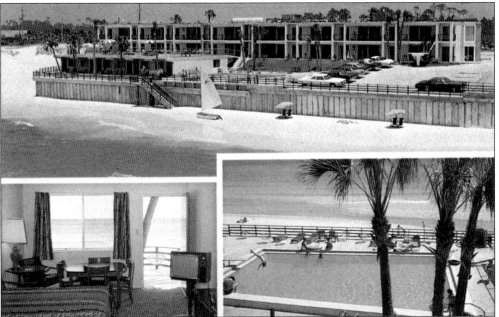

INN PARADISE, c. 1970s. The Inn Paradise is also one of those familiar places that is still standing. It is at Mara Vista Beach just west of Gulf World. One of the later motels built before the condo explosion started in the 1970s, the Inn Paradise had 42 elegant rooms, efficiencies, and cabana efficiencies. All had cable color television, phones, pool, sundeck, shuffleboard, and barbeque facilities to provide fun for the entire family.

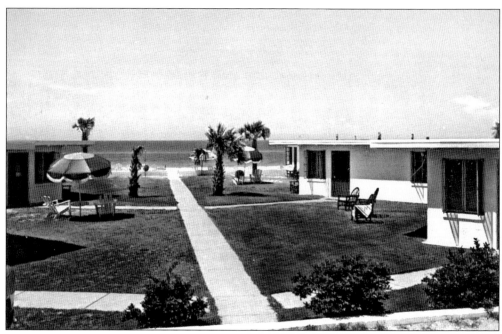

ST. REGIS COURT. The St. Regis Court was directly on the beach at Laguna Beach. It featured modern efficiency cottages with tile floors, including the kitchen and bath. Little Birmingham was just a little down the road for food and drink, and the Sea Horse was nearby as well for groceries and shopping.

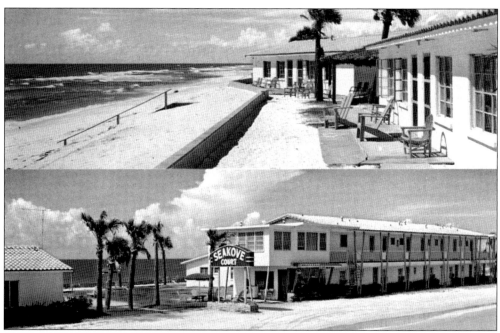

SEAKOVE COURT. The Seakove was located just a little west of the St. Regis Court (above) at Laguna Beach. It was also directly on the beach, sitting on a high sand dune with a small sea wall built to keep back the Gulf.

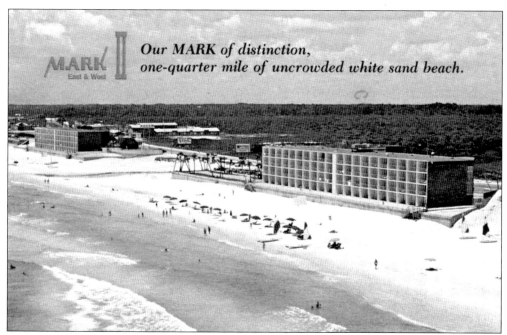

MARK II, c. 1980. The Mark II was just east of the old Holloway House and Gulf World at Mara Vista Beach. It consisted of two large four-story buildings right on the beach and advertised a quarter-mile of uncrowded white sand beach. This postcard was mailed back home to Indiana and said the senders had a good trip down.

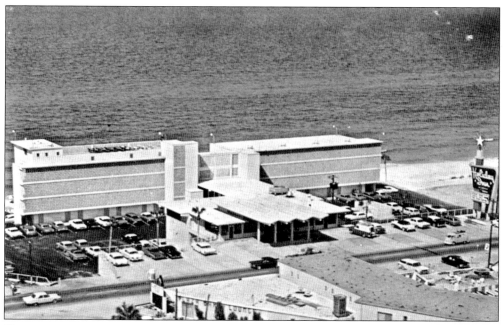

HOLIDAY INN, c. 1960s. This was the second Holiday Inn that Cliff Stiles built in the Panama City area. It was called the Gulfside Holiday Inn, since the first one he had built was not on the beach but located on St. Andrews Bay. It opened in 1964 with 100 rooms and four floors, making it the tallest structure on the beach at that time.

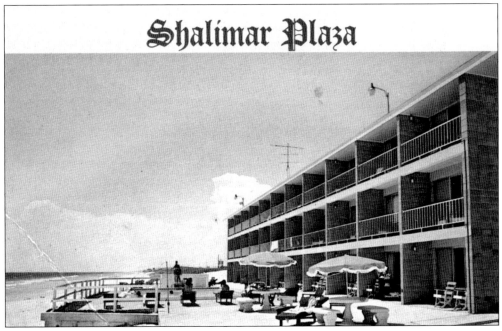

SHALIMAR PLAZA MOTEL. The Shalimar Plaza Motel was one mile west of the "Y" on Gulf Resort Beach. The Shalimar catered to families, as many of the motels did at that time, and was directly on the beach. The three-story structure had private balconies with a nice pool and patio. It was owned by Karen and Don Stephenson.

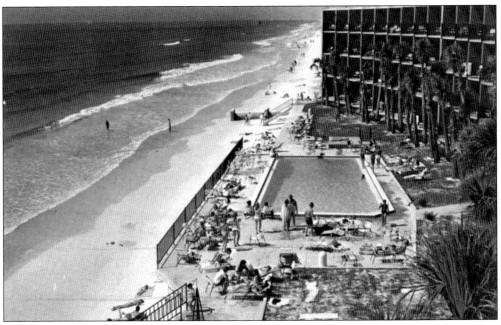

CASA LOMA MOTEL. The Casa Loma was located at the far end of Bahama Beach just before the Larkway Villas at Larkway Beach. At four stories, it was another of the later motels that were beginning to get taller. Done in Spanish décor, the Casa Loma had balconies overlooking the beautiful Gulf of Mexico. Still going strong, it is now known as the Best Western Casa Loma.

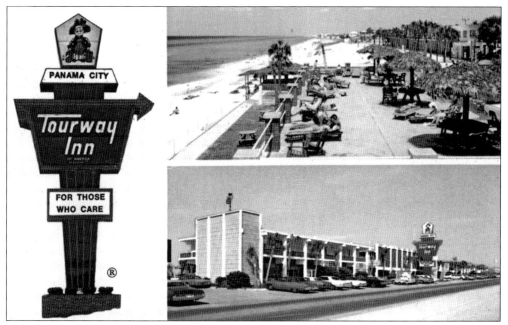

TOURWAY INN. The Tourway Inn, built in the 1960s, was just west of Peek's Beach Apartments on Florida Beach. It was on the beach side and had a wonderful patio and pool area. The author stayed there with his son on a "boys only" trip in his little white 1965 Volkswagen and recalls getting stuck in the sand. But it was no big deal; it was no problem to dig the sand from around the back wheels and push it right out.

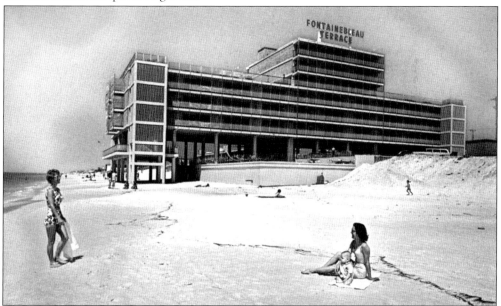

FONTAINEBLEAU TERRACE. The Fontainebleau Terrace has been used several times as a reference point and for good reason. The building is a little unusual and is still in the same place with the same name. It was the first high-rise on the beach with seven stories, 152 rooms, and even elevators. Each room had a view of the Gulf, and there was a huge indoor swimming pool, recreation room, and a roof garden.

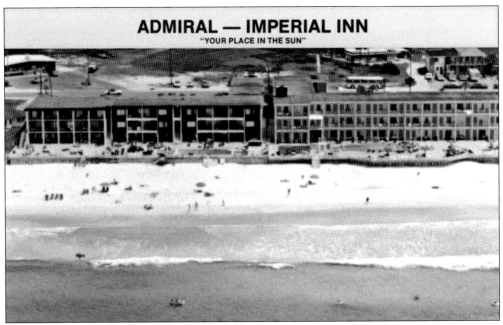

THE ADMIRAL-IMPERIAL INN. The Admiral and Imperial were formerly two separate motels that were combined to offer a total of 106 units. It was east of the "Y" at El Centro Beach next to the Seabreeze Motel and Restaurant. Directly on the beach, it sported two large pools and an expansive beach area.

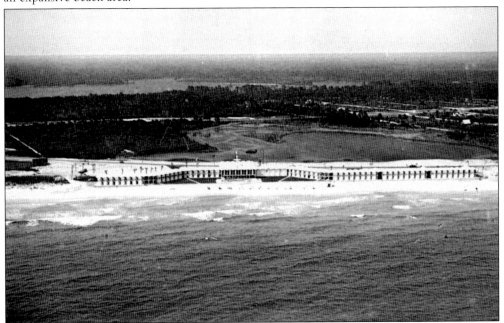

PARLIAMENT INN MOTOR HOTEL, c. 1960s. The Parliament Inn, built in the early 1960s, was located at Sunnyside Beach. It had 100 rooms, although it looks much larger, and included a restaurant (the Gaucho Lounge), banquet facilities, kitchenettes, and a gift shop. By the early 1970s, the name had changed to the Rountowner Motor Inn, and when Hurricane Eloise came through on September 23, 1975, it was destroyed.

Seven
Amusements and Things To Do

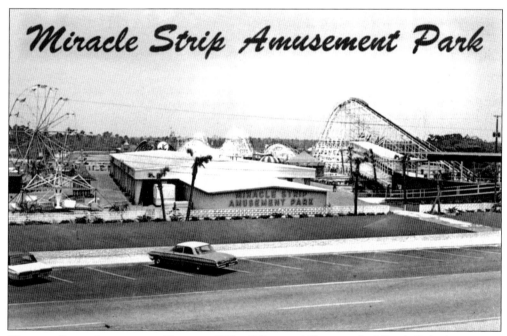

Miracle Strip Amusement Park, c. 1970s. What would become the Miracle Strip Amusement Park had begun some time after World War II. Jimmy Lark came along in 1963 and built the Starliner, a 2,403-foot roller coaster. Other additions came later as he began to enlarge the park. This 1970s view illustrates the scope of the park. At the left is the Scrambler and the Ferris wheel; however, this view doesn't show the other rides. One of the first fast-food establishments on the beach, Jack's Hamburgers from Birmingham, was built in the 1960s just out of view on the right next to the Starliner.

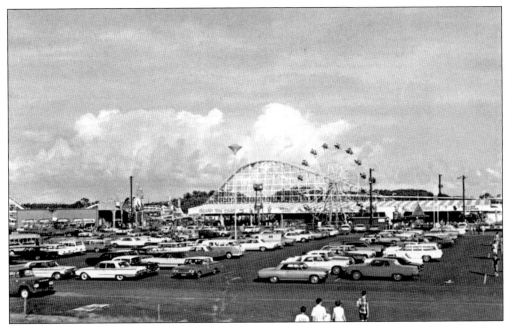

MIRACLE STRIP AMUSEMENT PARK, c. 1970s. This 1970s view of the Miracle Strip Amusement Park is taken from the west side parking lot. This afternoon view shows a good number of automobiles in the parking lot; by dusk, it would be overflowing with people of all ages. Unseen in this view is the Miracle Strip Observation Tower, built in 1967.

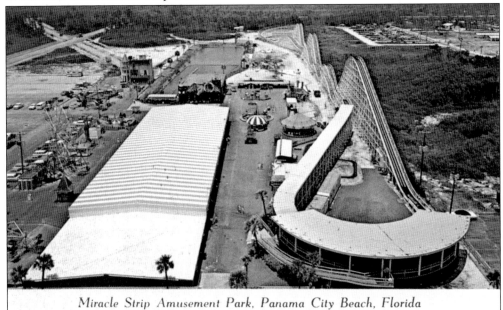

Miracle Strip Amusement Park, Panama City Beach, Florida

MIRACLE STRIP AMUSEMENT PARK. This view, taken from the Observation Tower across the road, shows some early rides and attractions in the park. Most rides are small, more suitable for the younger children. At the top you can see the Bumper Boats, one of the first rides added after the Starliner. Directly in front of the Bumper Boat ride is the ever-popular Haunted Castle, and over to the left, at the end of the pavement is the Old House.

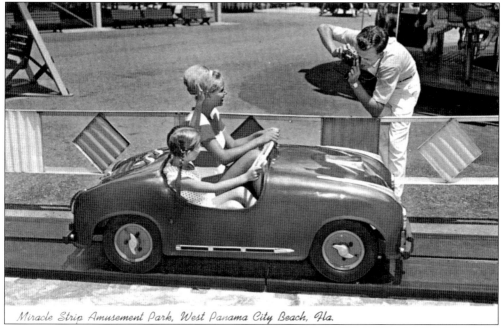

Miracle Strip Amusement Park, West Panama City Beach, Fla.

"HOT RODS." This postcard view illustrates one of the many kiddie rides for the small fries. It appears that a proud father is taking a picture of his little girl with her mother on this "hot rod" ride. The beehive hairdo puts the time frame in perspective. Many of the small children who once enjoyed these rides at Miracle Strip Amusement Park were bringing their children by the time it closed in 2004.

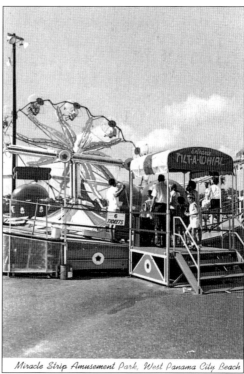

"TILT-A-WHIRL," 1974. The Tilt-A-Whirl has always been a popular ride at any amusement park, and the Miracle Strip Amusement Park was no exception. It was definitely not for small children, but the older kids liked it very much as did some young adults. This postcard, mailed to Mobile, Alabama, in 1974, has the writer apologizing to a friend for missing a function there with the "ladies" due to visiting with her son for a few days.

Miracle Strip Amusement Park, West Panama City Beach

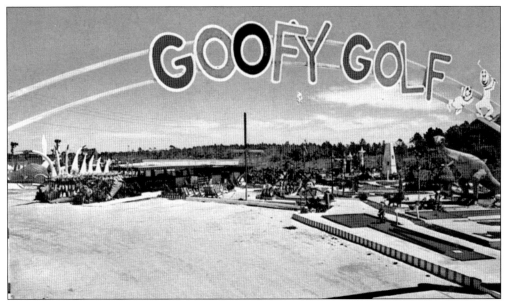

GOOFY GOLF. The Goofy Golf course began construction in 1959 west of what would become the Miracle Strip Amusement Park. It was built by Lee Koplin, who had been building miniature golf courses around the country since the 1940s. The grand opening was summer of 1959. He later said that he chose that site because it was in front of the County Pier so no one could later build in front and block the Gulf view.

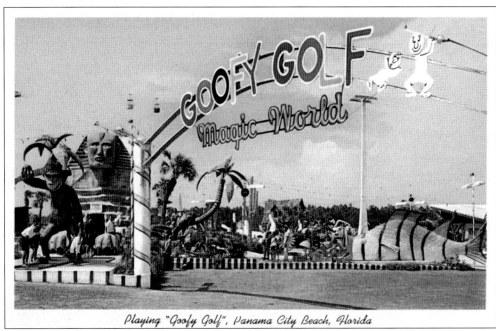

PLAYING "GOOFY GOLF." The entrance to Goofy Golf was right on U.S. Highway 98. The site is dominated by these huge characters that are part of the course. Lee Koplin liked his Magic World so much that he built his house in the middle of the course. The brontosaurus's legs were at his front door. The monkey's tail switched back and forth trying to block the golf balls. After all these years, Goofy Golf is still going strong.

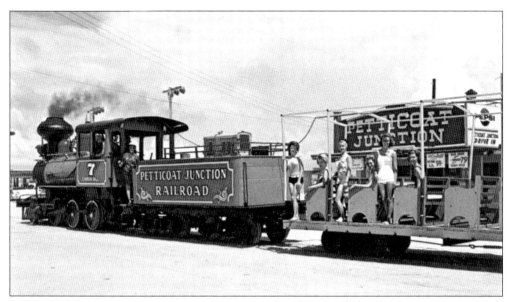

PETTICOAT JUNCTION RAILROAD. About 1965, the Churchwell family, down at Long Beach Resort, chose a spot across the highway from the casino to build the Petticoat Junction Railroad. These were not miniature trains but full-size working engines—three of them. This genuine coal-burning locomotive, seen in this view, was built in 1914 for the Argent Lumber Company in Hardeeville, South Carolina. Here, at Petticoat Junction, it pulled open coach cars and hauled people.

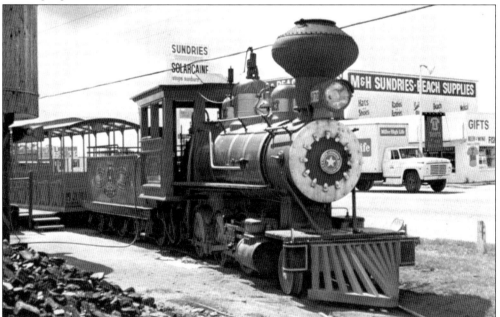

PETTICOAT JUNCTION RAILROAD. The coal pile used to fuel the steam locomotive can be seen in the foreground. At first, the Petticoat Junction Railroad just made a large circle and came back to the station. In order for it to have a destination, a Ghost Town was built at the rear of the property. The "town" consisted of a newspaper office, hotel, ice cream parlor, and a saloon. Later real businesses were placed in the town buildings.

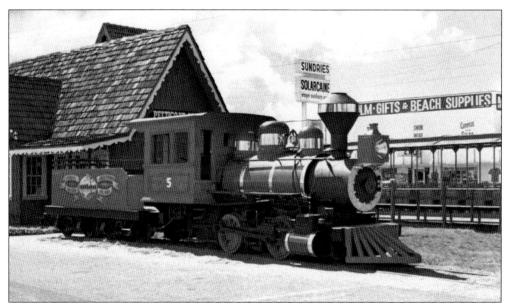

PETTICOAT JUNCTION RAILROAD. The ride to Ghost Town on the Petticoat Junction Railroad became quite exciting, with occasional train robberies and lots of shooting. When you got off the train at Ghost Town, there were now things to do. This locomotive, built in 1912, was used by the Armour Phosphate Company in Columbia, Tennessee, before coming to the beach. The old railroad site is now a huge Wal-Mart Super Center, and old Ghost Town is now an Applebee's.

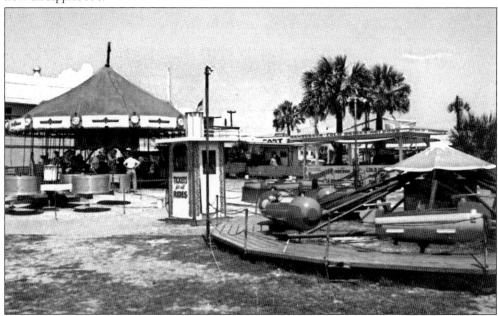

RECREATION AT LONG BEACH RESORT. On the west side of the boardwalk, down toward the Hang Out, was an area with amusement rides during the summer season. They were mostly rides for the little kids. The type of ride was always changing, and at the end of the season, they packed up and joined other groups that followed the state fair circuit. The author remembers that most of the time there was a Ferris wheel up near the casino building.

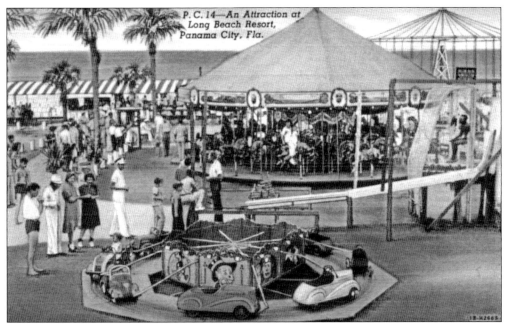

ATTRACTION AT LONG BEACH RESORT, *c.* 1941. This is an earlier view of the amusements located there in the 1940s. The style of the automobile ride in the foreground, with the comic strip characters of Jiggs and Maggie, dates this postcard to the 1940s. The coded number on this postcard indicates it was printed in 1941. At the top left, you can see the Hang Out, crowded with people as always.

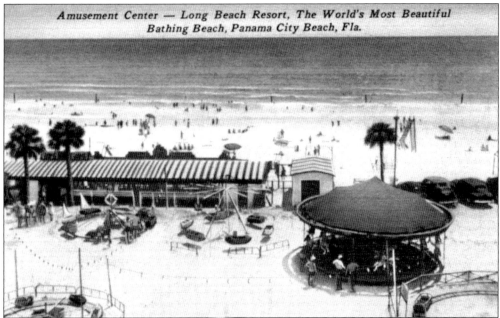

AMUSEMENT CENTER, *c.* 1930S. This is an earlier postcard view, possibly late 1930s, depicting rides that are somewhat simple when compared to those in the above view. There is no boardwalk down to the Hang Out, and the area behind the casino appears to be mostly open sand. This is most likely one of the earliest postcards published by Cooper's News Agency.

99

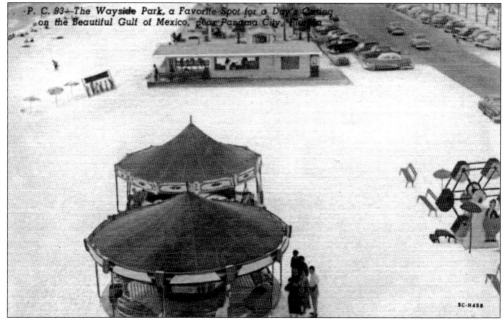

THE WAYSIDE PARK. This is an early view of some amusements at the Wayside Park on Mara Vista Beach. The rides are rather crude; in fact, the postcard is pretty crude. Although this postcard was produced in 1955 and mailed in 1957, the production style leads you to believe it is a much earlier view.

BOATING, 1913. This 1913 postcard view of a boat off the coast of Panama City includes a message from the sender to a lady in Belle Isle, Illinois. He notes that he had sent word to her by a Miss Whitney that she had received her last copy of *Woman's Home Companion* until another $1.50 came. This postcard, published for the Panama Jewelry Company, was mailed July 2, 1913.

Eight
Restaurants and Places to Eat

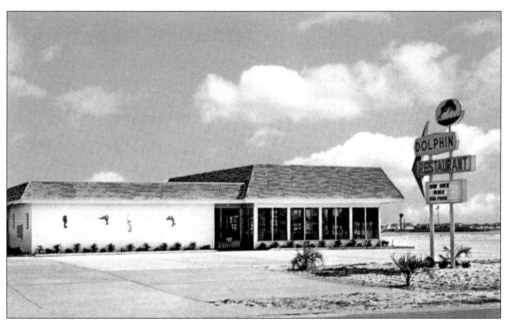

Dolphin Restaurant, c. 1967. The Dolphin Restaurant was located at 10015 U.S. 98 West near the Long Beach Resort Deer Ranch and the Signal Hill Golf Course in 1967. Mr. and Mrs. W. C. Hales were the owners. With "Now Open" on the sign at the front, it appears that the restaurant is newly opened. By 1971, it had become the Sirloin Steak House, which is believed to have been opened by Woody Miner. In the 1980s, a 46-foot statue was erected and called Sir Loin (see page 112). This postcard was produced by Henry McGrew Printing in Kansas City, Missouri, using a photograph by Bob Hargis of Panama City.

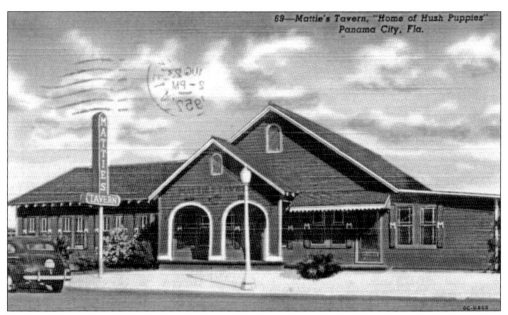

MATTIES TAVERN, 1950. Mattie Richbourg Campbell opened Mattie's Tavern in 1936 at 1130 Beck Avenue in St. Andrews. She evidently made some very good hush puppies. This was on the list of favorite places to go for Clark Gable, who was stationed at Tyndall Field during gunnery training in 1942. Tyrone Power, also at Tyndall at the same time, most likely accompanied Clark Gable a time or two. Mattie also owned Mattie's Motel across the street.

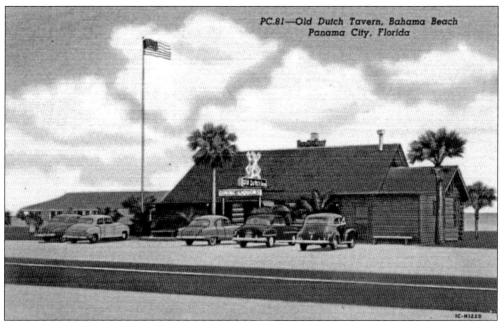

OLD DUTCH TAVERN, 1951. Frank Burghduff opened the Old Dutch Tavern in the 1930s at Dutchville, later Bahama Beach. Dutchville had been developed by Cliff Stiles of Birmingham. It was the first nightclub located on the beach and took two years to build. Two-and-a-half stories tall, it was built entirely of cypress logs, and the shingles were handmade. Located near that site today is the Days Inn Beach.

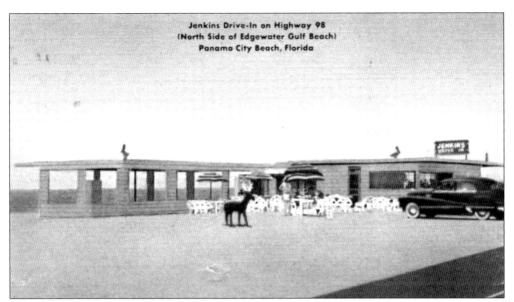

JENKINS DRIVE-IN, 1953. Jenkins Drive In was located at Edgewater Gulf Beach near the Edgewater Gulf Beach Apartments. Mr. I. R. Jenkins was the owner and manager. This postcard, mailed from Columbus, Georgia, on February 7, 1953, was addressed to *Name That Tune*, National Broadcasting Company in New York. The five songs the writer picked to name were "A Weaver of Dreams," "Domino," "My Favorite Song," "Indian Love Call," and "The Sweetest Story Ever Told."

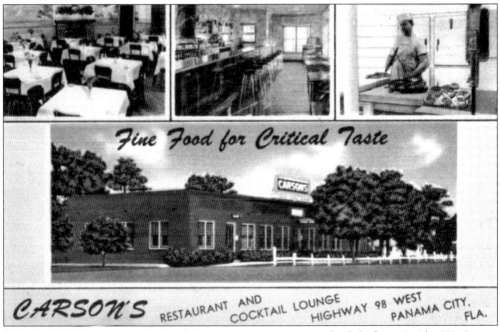

CARSON'S RESTAURANT, c. 1950. Carson's Restaurant was built before 1947 by W. Carson Gorman. It was located at 3100 West Coastal Highway 98 in St. Andrews. By 1957, the owner was Jimmy Mann and the name was now Carson's Seafood Restaurant. A package store was located on the left side of the building. The specialties at Carson's were seafood, steaks, and chicken.

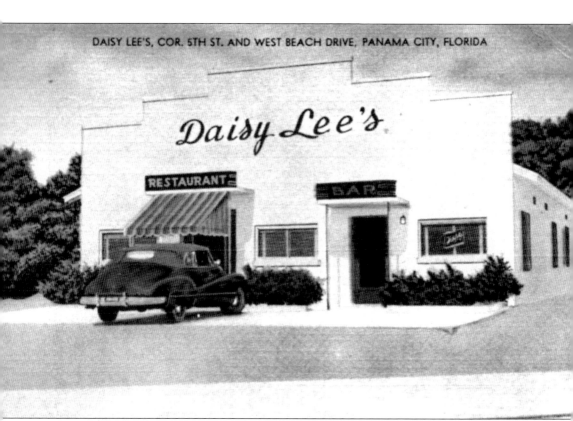

DAISY LEE'S RESTAURANT, c. 1940s. Daisy Lee's Restaurant was located at 508 Mulberry Avenue, next to Fifth Street and West Beach Drive. West Beach Drive had been the original route for U.S. Highway 98 and is now Business Highway 98. Conveniently located only a few blocks from downtown and the Panama City Marina, it must have been a popular place to eat and have a drink. It was open by the late 1940s and boasted of serving the finest in steaks, seafood, and chicken, prepared as you like it with your favorite mixed drink available. Daisy Lee was the daughter of Mattie Richbourg Campbell, who owned Mattie's Tavern not far away. Look closely and you can see the Schlitz beer sign in the right front window. Daisy Lee's operated well into the 1960s and today is the site of the Nextel Building. The building still maintains its basic shape with only minor modifications to the front. (Postcard courtesy of Janet Givens.)

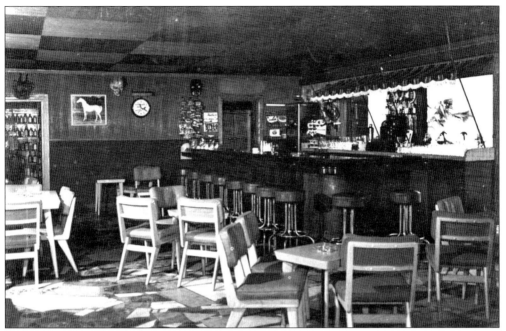

LITTLE BIRMINGHAM. Little Birmingham was built in 1936 by J. B. Lahan of Birmingham. It was located at Bahama Beach near the Old Dutch Inn. This postcard view, published by Robertson Photo Service of Panama City, is an interior shot of the lounge, which was most likely the busiest spot in the place. The manager and possible owner at this time was Carl Fernandez.

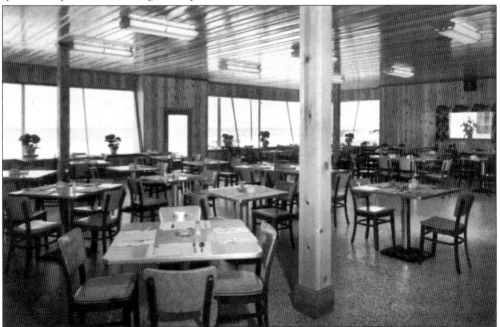

SEABREEZE DINING ROOM. The Seabreeze Restaurant was at 16806 Highway 98 at El Centro Beach. It was between the Sky Way Motel and the Admiral-Imperial Inn. It was adjacent to the Sea Breeze Motel and the Sea Breeze Package Store. The Seabreeze Dining Room has long since disappeared, but the Sea Breeze Motel was still going strong next door well into the 1990s.

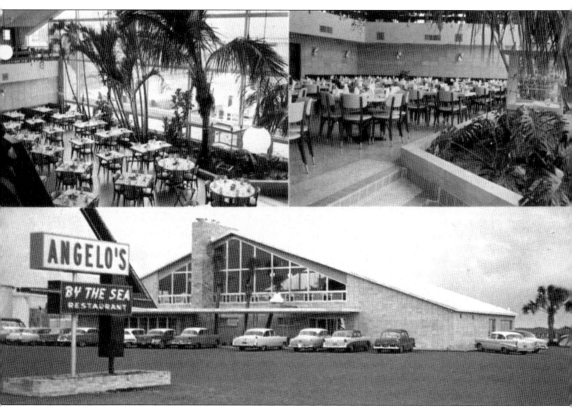

ANGELO'S BY THE SEA, *c.* **1950s.** Angelo Gus Butchikas opened his first restaurant at 29 East Fifth Street in downtown Panama City in 1951. He later moved to this location at 711 West Beach Drive, which was the site of the first Holiday Inn Motel in Panama City built by Cliff Stiles. By the time Angelo's By The Sea opened there, it had become a Best Western Motel. St. Andrews Bay was at the rear, and across the street was Johnson Bayou. In 1958, Angelo moved to the current location at 9527 Highway 98 West, where you still see that familiar trademark, Big Gus, the humongous steer who first appeared out front in 1970. Angelo Butchikas died an untimely death in a traffic accident in 1963, and since that time, his son, George, continues to serve those wonderful, sizzling, mouth-watering steaks. Currently the location of this Angelo's By The Sea is the Days Inn Bayside.

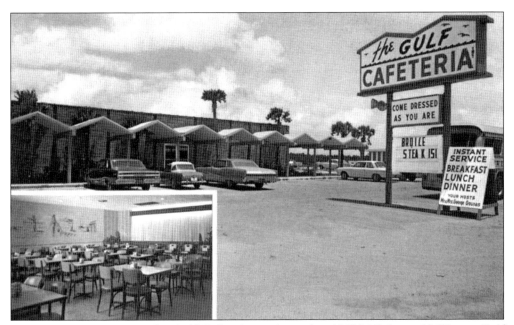

THE GULF CAFETERIA. The Gulf Cafeteria was located at 12628 Highway 98 West at Gulf Beach, across the street from the Breakers Restaurant. Owned and operated by George Gouras, they advertised they were the only cafeteria on "Florida's Miracle Strip" and were famous for their roast beef, seafood, and desserts. It was there for a long time, but now Bishops Buffet has taken its place.

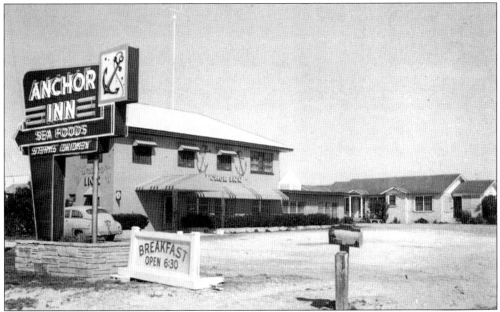

ANCHOR INN RESTAURANT, c. 1940s. The Anchor Inn Restaurant operated in conjunction with the Anchor Inn Motel. Both were located in Florida Beach across from the Fontainebleau Terrace. The owners and operators were Mr. and Mrs. George F. Godwin, and they specialized in seafood, steak, and chicken, just like almost every other restaurant down there. You can see from their sign out front that they opened at 6:30 a.m. for breakfast.

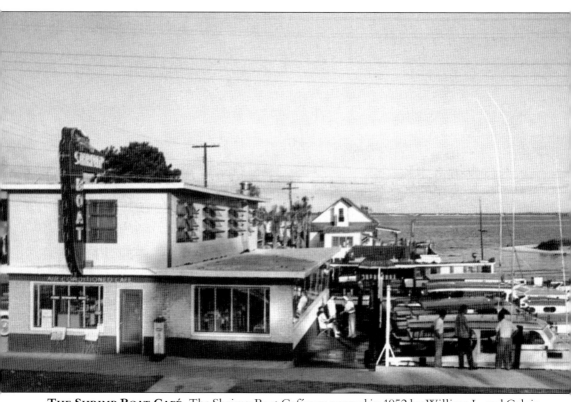

THE SHRIMP BOAT CAFÉ. The Shrimp Boat Café was opened in 1952 by William L. and Calvin L. Smith in St. Andrews at 1201 Beck Avenue. At that time, U.S. Highway 98 came right by there on Beck Avenue. It was located on Smith's Yacht Basin and was built mostly out over the water. In the 1970s, Lowe Smith purchased the Shrimp Boat and built the Copa Cabana Motel across the street. The author recalls taking his children there in the late 1960s to eat supper in the evening and watch the fishing boats return while dining inside by the front window. He remembers looking out that window himself with his father many years before. The view from that window was pretty much the scene that appears on the postcard on page 25.

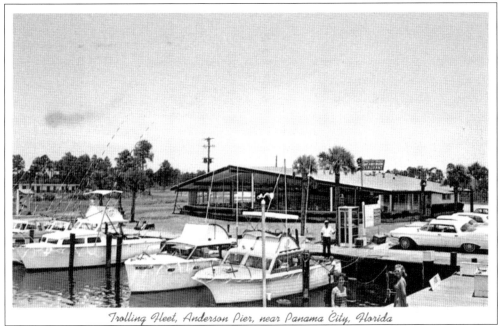

TROLLING FLEET, ANDERSON PIER, *c.* **1960s.** This postcard directs attention to the trolling fleet of fishing boats. However, directly behind the boats is a 1960s view of Captain Anderson's Restaurant, before the Patronis family purchased it. It appears quite small, especially if you have visited Captain Anderson's Restaurant recently. The motel units in the far left background are part of the old Tom-Ric Motel and Marina that was located behind Captain Anderson's (see page 59).

THE ESCAPE RESTAURANT, *c.* **1950s.** The Escape Restaurant and Lounge was located adjacent to the Escape Motel at 11115 on U.S. Highway 98 West, between the Miracle Strip Amusement Park and Petticoat Junction. They had 60 luxurious units directly on the Gulf of Mexico. The Holiday Inn #3 was built on this site later and still remains, now known as the Holiday Inn Sunspree Resort.

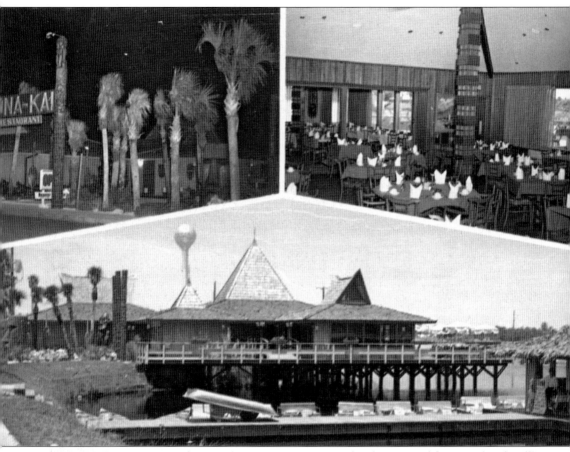

KONA KAI RESTAURANT. The Kona Kai Restaurant sat on Lake Flora, named for J. E. Churchwell's wife, at 10292 U.S. Highway 98 at Long Beach Resort. Lake Flora was used for some paddleboats and a pirate ship that were part of the Long Beach Resort complex across from the casino. The Long Beach Resort water tank can be seen in the background on the lower portion of this multi-view postcard. The Kona Kai advertised that dining on the shores of an enchanted lagoon is an unforgettable experience, the epicure of gourmet Polynesian-American foods. They also noted that they had a cocktail lounge. The author enjoyed eating there in the late 1960s and still has the handwritten recipe for their Banana Tiki, provided by the bartender on a cocktail napkin. In the 1990s, it became the Seafare Restaurant, and currently it is Pompano's Restaurant. They serve up some pretty good food, complete with a sushi menu, from that same building.

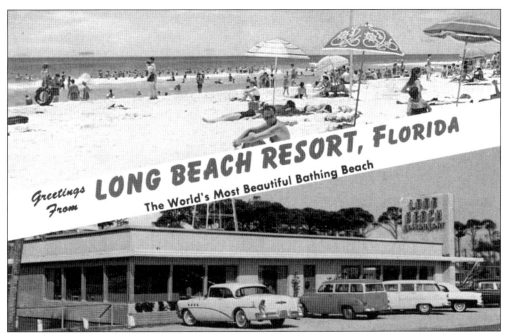

LONG BEACH RESORT RESTAURANT, c. 1950s. The Long Beach Resort Restaurant, a part of the famous Long Beach Resort, was located at 10510 on U.S. Highway 98. This multi-view postcard has a beach scene behind the Hang Out at the top and the Long Beach Restaurant at the bottom. They advertised an air-conditioned restaurant located at Long Beach Resort with fine foods at moderate prices, making Long Beach Resort Restaurant an ever-favorite rendezvous.

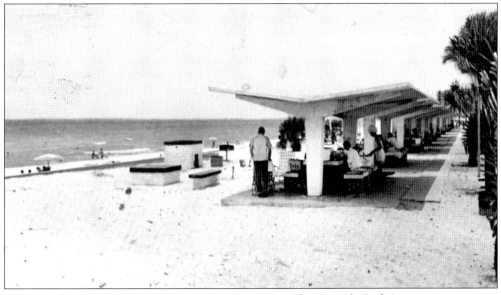

WAYSIDE PARK ON THE MIRACLE STRIP, c. 1970s. The Wayside Park is not a restaurant or café, but it was a popular place to have a picnic. It was located on Highway 98 up at Wayside Beach near the South Pacific Motel. Looking at these covered picnic tables, you will note they are all full and everyone is chowing down. You can tell by the shadows cast from the shelter that it is high noon and the dinner bell has rung.

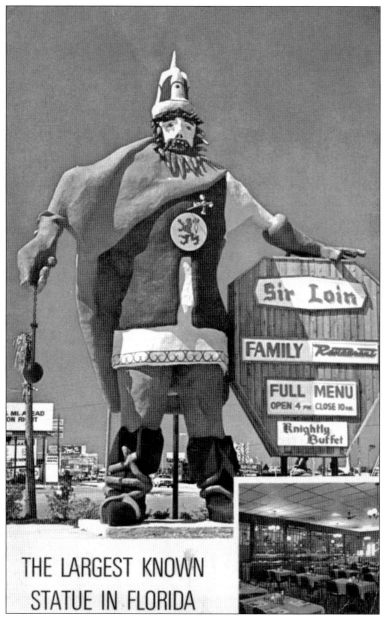

SIR LOIN FAMILY RESTAURANT, c. 1980. This originally opened in 1967 as the Dolphin Restaurant (see page 101), and in 1971, it became the Sirloin Steak House. It was located at 10015 Highway 98. In the 1980s, a 46-foot-tall statue, named Sir Loin, was erected outside, and the name was changed to the Sir Loin Family Restaurant. At that time, it was owned by Mr. and Mrs. H. E. York. You can see on the postcard view they advertised a full menu with a "Knightly Buffet." If you get out your magnifying glasses again, you can see the Sui-Slide sign, a water slide ride at Petticoat Junction, just to the right of Sir Loin's left boot. By 1990, the restaurant had closed, and in its place was the Shell Island Gift Shop, owned by Thomas R. and Debbie Fowler. The Sir Loin statue did not go to waste however, and after some modification, he became King Neptune. King Neptune eventually disappeared, and the Heatwave Gift Shop is currently located there.

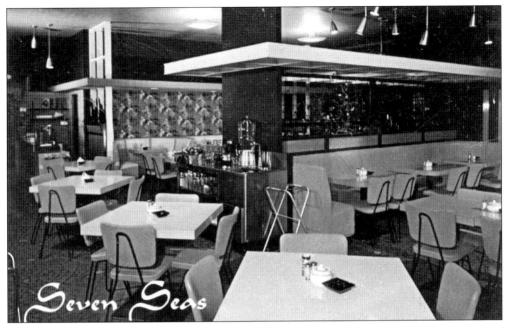

SEVEN SEAS RESTAURANT, c. 1970s. The Seven Seas Restaurant was located at 18 West Fifth Street in downtown Panama City. Johnny Patronis, George Gouras, and A. I. Christo opened it in 1953. In 1955, Jimmy Patronis joined his brother, Johnny, and Gouras was bought out. Then in 1967, the Patronis brothers left to purchase Captain Anderson's Restaurant. A. I. Christo continued to run the Seven Seas until it went out of business in 1978.

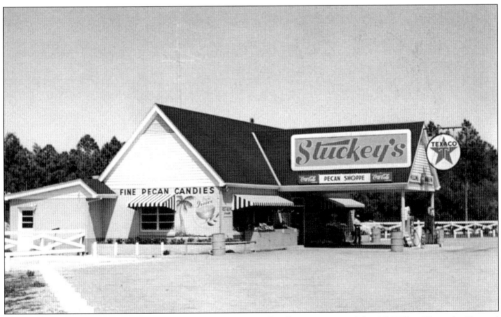

STUCKEY'S PECAN SHOPPE, c. 1950s. This Stuckey's was opened in 1967 by Dennis C. and Martha Rich at 7202 West Highway 98. As with all the Stuckey's shops, they sold pecans, pecan candies, souvenirs, gifts, and hickory-smoked hams and bacon. As indicated in this postcard view, they also sold Texaco gasoline products. By 1999, it had become Rich's Gift Shop.

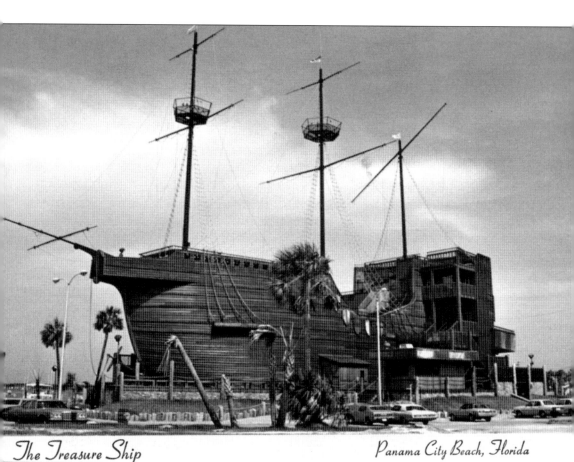

The Treasure Ship Panama City Beach, Florida

THE TREASURE SHIP, *c.* **1980.** The Treasure Ship appeared on the scene in the late 1970s next to Treasure Island Marina, and eating on Thomas Drive has not been the same since. As you can see in this postcard view, it really does look like a treasure ship. All that is missing is the skull and crossbones flag. The Treasure Ship is a 200-foot replica of a Spanish galleon built on the shores of Grand Lagoon, overlooking St. Andrews Bay and, of course, Thomas Drive as well. There are a variety of dining choices available. The Main Dining Room on level two has a panoramic view of charter boats, sightseeing cruises, and pleasure craft on the water. Captain Crabby's on level three features open-air dining with cocktails at the Deck Bar. And on the dock level is Hooks Grill and Grog featuring Caribbean flavors with a splendid view of the charter fishing fleet. No matter which choice you make, they all provide a unique setting for dining and entertainment.

Nine

MISCELLANEOUS

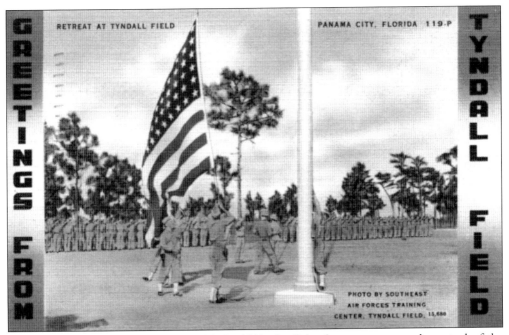

RETREAT AT TYNDALL FIELD, 1944. In 1941, the federal government took control of the property on the East Peninsula for the location of a gunnery school. The first military personnel were transferred there from Maxwell Field in Montgomery, Alabama. By 1944, Tyndall was training 500 gunners each week. One of those gunners was Clark Gable, who received his silver wings on January 6, 1943. He always created a sensation when he went into town to one of his many favorite places to go. Other movie stars and celebrities there were Tyrone Power, Glenn Davis, and Ted Williams. The students practiced with live ammunition and fired at a towed target, mostly pulled by female pilots who were members of the Women's Air Service Pilots or WASP.

HEADQUARTERS OF TYNDALL FIELD, c. 1942. This postcard view, published by the Dothan Cigar and Candy Company of Dothan, Alabama, shows the headquarters building at Tyndall Field. At this time, it was still only designated a field but would become Tyndall Air Force Base in 1947. The 28,000-acre Tyndall Field was named for Frank B. Tyndall, a World War I flying ace. A base newspaper, the *Tyndall Target*, began publishing there in 1942.

WEST GATE TO TYNDALL FIELD, c. 1940s. This view of security at the West Gate at Tyndall Field during wartime is a far cry from the way it is today. This postcard was mailed from Dothan, Alabama, in 1952, a good while after it was produced. Since postcards were printed by the thousands in Dothan, most likely this one had been lying around for a while. The writer relates to the recipient that this is where Don was stationed.

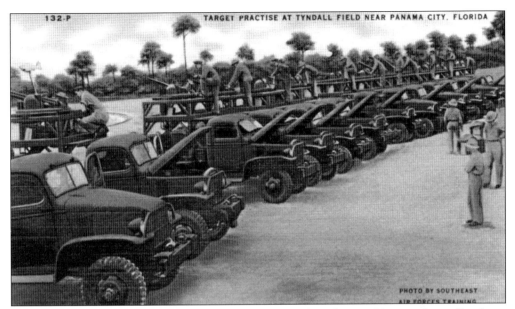

TARGET PRACTICE AT TYNDALL FIELD, c. 1940s. When the 28,000-acre piece of land was acquired for Tyndall Field by the federal government, several communities were displaced that had been there for many years. In 1941, these communities consisted of over 1,000 homeowners. One of the earlier homeowners was Jose Massalina, a free Spanish black who settled there in 1830. In 1902, Massalina died at the age of 111 and is buried at Tyndall.

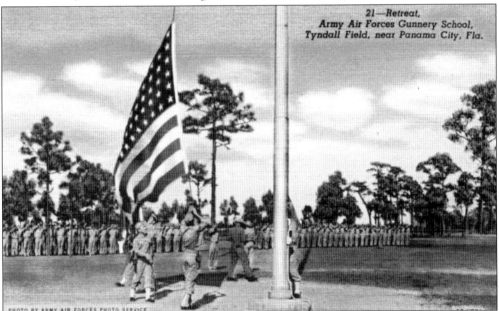

RETREAT, TYNDALL FIELD, 1942. This postcard gives an inspiring view of Old Glory with 48 stars. Ironically Tyndall Field opened the day before the attack on Pearl Harbor. Col. W. A. Maxwell, the first commander at Tyndall Field, initially had his office at the old Panama City Hall. He piloted the first AT-6 Trainer there and landed at the Reaver Airport on Balboa and Eleventh Street at St. Andrews on November 5, 1941. By 1944, they were also training B-17 and B-24 pilots.

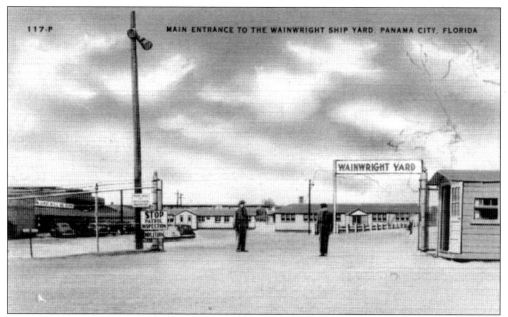

MAIN ENTRANCE WAINWRIGHT SHIP YARD, c. 1940s. This is a view of the main gate at the Wainwright Ship Yard. It was constructed at a cost of $62 million on 112 acres at Dyer's Point and built Liberty ships for World War II. In three years, 102 Liberty ships and 6 T-1 tankers were built there. The first Liberty ship, the *E. Kirby Smith*, rolled out on December 30, 1942. By the end of the war, Wainwright had 18,000 workers.

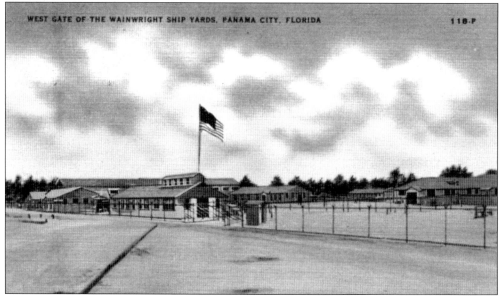

WEST GATE WAINWRIGHT SHIP YARDS, c. 1940s. This postcard view shows the west gate of the Wainwright Ship Yards. Wainwright had a weekly newspaper called *The Wainwright Liberator*. The shipyards closed after the war, and after 11 long years of negotiating, the navy finally agreed to sell the old shipyard to Panama City in September 1957. The *Stephen Furdek*, the 40th Liberty ship built at Wainwright, returned in June 1970 to be scrapped at the same location it had been built.

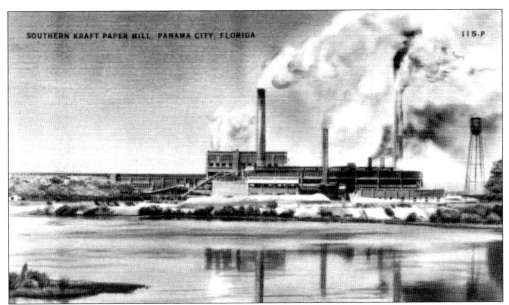

SOUTHERN KRAFT PAPER MILL. This is a postcard view of the Southern Kraft Division of International Paper Company at Panama City. The International Paper Company announced plans in April 1930 to build a paper and pulp mill there. A sawmill had just closed in Millville in 1929, and local residents were desperate for jobs. In 1931, the International Paper Company opened the first paper mill in Florida at the east end of Millville at Bay Harbor.

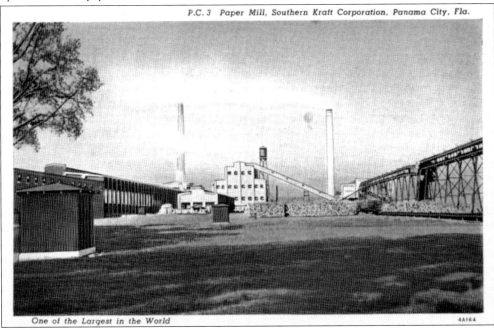

PAPER MILL, 1934. This 1934 postcard view of the Southern Kraft Paper Mill shows how it appeared three years after being constructed. They claimed to be one of the largest in the world and the largest and most modern of the six paper mills owned by International Paper Company. Built at a cost of $6 million, they claimed in 1934 to have been in operation 24 hours a day continuously since opening.

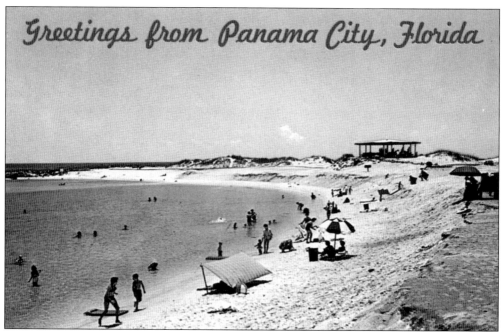

GREETINGS. This is a postcard view of the St. Andrews State Recreation Area and its smooth crystal-clear water protected by the jetties. It opened in 1951 and consists of more than 1,260 acres. Two fishing piers and the jetties provide an opportunity to fish for mackerel, redfish, flounder, seat trout, bonito, dolphin, and bluefish. There are 176 camping sites with electricity, water, picnic tables, and grills.

FISHING FROM THE JETTY. This is another view of the jetty at St. Andrews State Recreation Area, which is actually a state park. The recreation area is on both sides of the Pass, cut in 1934 to provide an easier route for ships into St. Andrews Bay. The east side is called Shell Island, and, of course, the west side is Thomas Drive. A boat launch provides easy access to the bay or the Gulf.

NOAH'S ARK. This eye-catching structure, Noah's Ark, was built by the United Methodist Church Beach Ministry and is located at 12902 West Highway 98, across the road from the Holiday Inn Beachside. It was used as a church, and the first pastor was Rev. Jim Raines. It also provided group retreat accommodations for Methodist church groups.

THE PINK CLAM, c. 1970. The Pink Clam, located at 8219 West Highway 98, was a self-acclaimed beautiful and unusual gift shop. It appeared on the scene around 1970 and was owned by Orville S. Gibb. They advertised gifts from the four corners of the world that included Fenton glassware, rattan, wicker ware, imported wood, furniture, brass, pottery, china, and crystal. In 2005, it is the home of Miles Interiors.

PANAMA CITY BEACH—PANAMA CITY, FLA., *c.* **1930s.** This is an early-1930s postcard view published by E. W. Masker, who provided most of the early photos for postcards in the Panama City area. The front of the postcard indicates that this is a "Panama City Beach" scene. At that time, the only Panama City Beach was the Panama City Beach Hotel (see chapter three), so this apparently is a scene on the beach at or near there.

THE APALACHICOLA RIVER. The Apalachicola River flows east of Panama City and empties into the Apalachicola Bay. This river is the dividing line separating the Eastern and Central Time Zones through the Panhandle of Florida. This postcard view from Alum Bluff, one of the highest elevations in Florida, was a location fortified by the Confederate army during the Civil War to prevent Union gunboats from penetrating the Confederacy from the south.

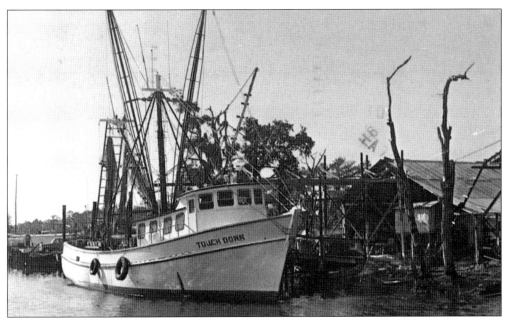

GULF COAST SHRIMPER, c. 1970s. Pictured here on this postcard view is the *Touch Down*, a shrimp boat docked at some location on St. Andrews Bay. This postcard was mailed in October 1977 to Dayton, Ohio. The sender says they are getting warm and full of seafood and will be going on to St. Augustine and then to Savannah, Georgia, for two or three days.

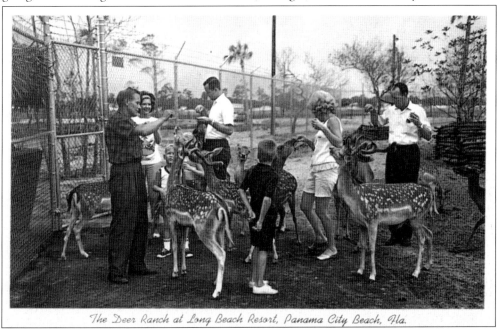

DEER RANCH AT LONG BEACH RESORT, c. 1960s. The Deer Ranch was part of the many facilities at Long Beach Resort. It had over 100 deer and sheep and one buffalo. Although connected physically to the Long Beach Resort property, it was actually on Thomas Drive at 9820. It appeared by 1967 and was gone by 1970. Children and adults alike, as you can see in this postcard view, enjoyed petting and feeding the deer.

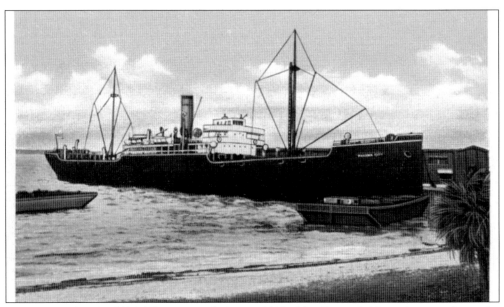

SS *Panama City*, c. 1936. This postcard view, published by Cooper's News Agency, shows the SS *Panama City* apparently docked somewhere around Panama City. This appears to be another altered postcard, as it seems unlikely that a ship this size could get that close to the beach where the water is so shallow. As mentioned elsewhere in this publication, oftentimes a postcard is altered or enhanced in an attempt to make it more pleasing to the eye.

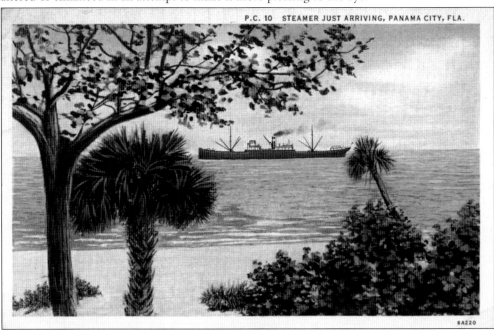

STEAMER ARRIVING, c. 1936. Here is a postcard view of a steamer approaching Panama City. This postcard, published by the Ashville Post Card Company, was mailed to Birmingham, Alabama, on December 28, 1936. A mother is sending this postcard to one of her daughters and relates that she had so much to tell them all when they get home. She further states, "It is so beautiful here, wish you were here, and will see you about Friday."

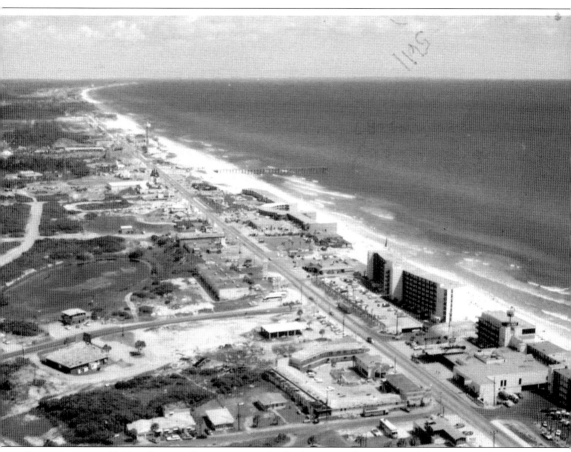

GREETINGS, c. 1980. This aerial view postcard is looking east from the Holiday Inn #2, at the bottom right corner, down what is now Front Beach Road toward the Miracle Strip Amusement Park. Get out your magnifying glass again and look for the old Miracle Strip Observation Tower; it is toward the top on the beach side of the road. Across from there is the Miracle Strip Amusement Park. Across the parking lot and moving west is Jungle Land, which later became Alvins Magic Mountain Mall. Next to that is Goofy Golf with two of the towers that supported the Sky Ride, which was long gone by this time. The Chateau Motel, with its rounded front, is on the right just past the County Pier. The old Plaza Motel can be seen across from the Holiday Inn. The author can recall in the late 1950s that a two-foot shark was placed in the pool behind the Plaza Motel by unnamed persons. The poor shark was scared to death. In this view, the huge condominiums had not appeared, and the beach still had that open feeling.

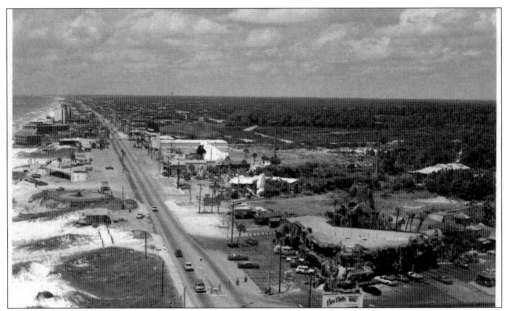

PANAMA CITY BEACH. This view is looking west from the Observation Tower. Alvin's Magic Mountain Mall, the former Jungle Land, is at the bottom right. Goofy Golf is visible in the middle of the view, and behind Goofy Golf are two tall towers, the only remaining parts of the old Sky Ride. Look closely at the Goofy Golf layout and you will see the home of Jimmy Lark behind the brontosaurus's leg.

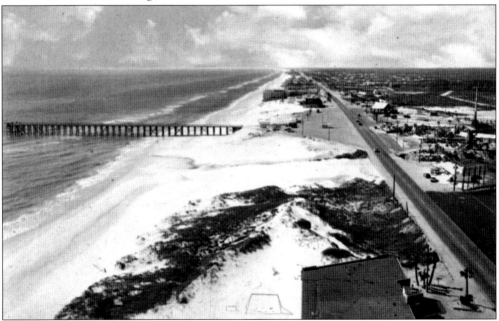

PANAMA CITY BEACHES, c. 1960s. This postcard provides an earlier view of the Goofy Golf site. You will notice that Jungle Land has not yet been built on the east side of Goofy Golf, and one of the towers for the Sky Ride can be seen to the rear. It is really nice to remember when you could see all that open space and the sand dunes. The County Pier to the left is a good reference point.

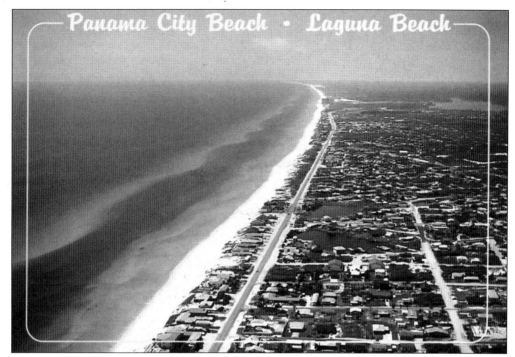

LAGUNA BEACH. This great Tim Allen photo makes a wonderful panoramic view of the beautiful white beaches along Laguna Beach. You will notice the absence of high-rise buildings with many single-family houses and cottages still plentiful. Unfortunately this is rapidly changing as the never-ending development along the beach keeps gobbling them up.

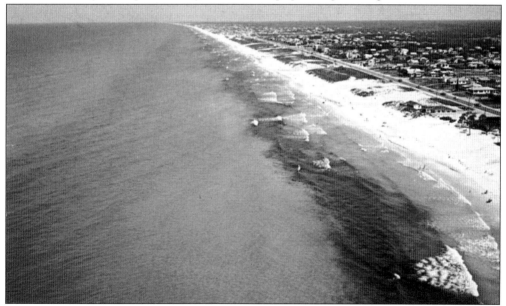

AERIAL VIEW OF LAGUNA BEACH, c. 1970. And here is one more 1970s aerial view of Laguna Beach, when it was still mostly private houses and cottages for rent. Many of the "older" folks had their first taste of those beautiful white-sand beaches up at Laguna Beach. City Directory. Panama City: R. L. Polk and Company, 1935–1990.

BIBLIOGRAPHY

Hollis, Tim. *Florida's Miracle Strip: From Redneck Riviera to Emerald Coast*: Jackson, MS: UP of Mississippi, 2004.
Historical Society of Bay County, Inc. *Panama City Historical Sites Survey, 1987, Revised 2002*: Panama City, FL: Historical Society of Bay County, Inc., 2002.
Houpt, Ann Pratt. *Parker*. Charleston, SC: Arcadia Publishing, 2003.
Nicholson, Susan Brown. *The Encyclopedia of Antique Postcards*. Radnor, PA: Wallace-Homestead, 1994.
Smith, Jack H. *Postcard Companion: The Collector's Reference*. Radnor, PA: Wallace-Homestead. 1989.
Smith, Jan. *Panama City Beach*. Charleston, SC: Arcadia Publishing, 2004.
Smith, Tommy. *The History of Bay County From the Beginning*. Panama City, FL: BeneMac Publishing, Inc., 2000.
———. *The History of Bay County in Pictures*. Panama City, Florida: BeneMac Publishing, Inc, 2001.
Smith, Tommy, ed. *Explore Historic Downtown Panama City & St. Andrews*. Panama City, FL: BeneMac Publishing, Inc., 2002.
Staff, Frank. *The Picture Postcard and Its Origins*. New York: Frederick A. Praeger, 1966.
Weeks, J. D. *Birmingham In Vintage Postcards*. Charleston, SC: Arcadia Publishing, 1999.
Willoughby, Martin. *A History of Postcards*. London, England: Bracken Books, 1994.
Womack, Marlene. *The Rich Heritage of Panama City Beach and Communities of Bay County*. Montgomery, AL: Community Heritage Publications, 2001.
Wood, Jane. *The Collector's Guide to Post Cards*. Gas City, IN: L. & W. Promotions, 1984.